ART
From the Mayans to Disney

ART
FROM THE MAYANS
TO DISNEY

JEAN CHARLOT

Essay Index Reprint Series

BOOKS FOR LIBRARIES PRESS
FREEPORT, NEW YORK

STANDARD BOOK NUMBER:
8369-1399-X

LIBRARY OF CONGRESS CATALOG CARD NUMBER:
78-99623

PRINTED IN THE UNITED STATES OF AMERICA

CONTENTS

5

6

ILLUSTRATIONS

7

8

1. FOR PEOPLE OF GOOD WILL

THERE is no mystery about Art. It is one of the simplest things on earth. You know if a piece of furniture is made of good or bad wood, according to the grain, color and density. From the thickness of the beam, the perfection of the joints, you judge the worth of the workman, and if it is waxed with beeswax that smells good, you know that he finished his work with the gladness of perfection. Thus concerning the material. As for the looks, you relish the proportions if they are planned with orderly wisdom; you may prove or disprove its beauty by sitting on the chair or piling up your dishes in the cupboard, your linen in the chest.

A bad piece of furniture is the useless one. The table wobbles, the back of the chair catches the cloth of your coat, sometimes with a nail, other times by elaborate carvings. The screw of the microscope, the dial of a sextant, the face of man, have a beauty that comes from the perfect collaboration of each detail to the whole.

Suppress one and you create a freak. The horror engendered by the blind eye lies solely in its uselessness. In the same way the good work of art is (a) made with an honorable material, (b) ordered to a useful end.

a: Material should be good from the start, for the working of it into an 'art object' cannot modify its being. As the cabinet maker chooses with a purpose between cedar and pear wood, the painter or sculptor should be fastidious. He should know the origin and components, the weight, the density, the permanency of matters. He should also learn to respect their natural qualities. As a horticulturist prunes and grafts, the conscientious artist corroborates nature. To transmute a thing into another may seem the Philosopher's stone to morons, but it seldom happens without mayhem. The sculptor who gives to clay the appearance of stone, the painter who with colored pigments pretends to open illusive windows, what does their work consist of? By a legerdemain they make a natural being vanish, clay or canvas, and give us a monstrosity in return. They act like those wicked mendicants of yore who for profit, en-

caged children into such small pens that their heads alone would grow to bizarre proportions, and pitying crowds would assemble and rain coins upon them.

b: Some ends are so ingrained in an object as to leave no doubt: water has cleansing power, a knife cuts, etc., but for others the end is more devious. To talk is to make a noise but words may be the carriers of thought, the latter may lead to action. Painting deals with plastic objects in the same way that the verb deals with words. Those objects are ideographs of thought. The painting which limits itself within the plastic universe is like the conversation of the mad man, which is a thoughtless noise.

As there were many steps on the ladder that Jacob envisioned, there is, reflected in painting, a hierarchy of thought. Those imbedded in sensations are lowest. To satisfy their cravings, pictures of meat and fruits, and of nude women are useful, although less than the originals. On the next rung sits sentimentality, this well-bred twin of sensuality. For her; musicians, children at play, cats in baskets, family photographs, etc. Still higher comes this class of pictures:

historical compositions, portraits of heroes, the likenesses of Saints, which make us wish to match their feats. Such are the frescoes of Raphael, the compositions of Poussin and David.

It is paradoxical that the fashion of the day respects only the likeness of vulgar objects, still-lives or landscapes, while the great historical styles are despised as story-telling. The public learns to gabble technical terms, is prodded by the critics into invading the artists' studios. Theatres do not open to customers at rehearsals, and the wings are kept free for stagehands. We, painters, would also appreciate privacy when at work. When ready, our show is free for all to see. We are pleased if the pain we have taken pleases you. If you are irked, close your eyes, it vanishes.

"Deer Ceremonial." Detail from 'Camara Vase.' ☞

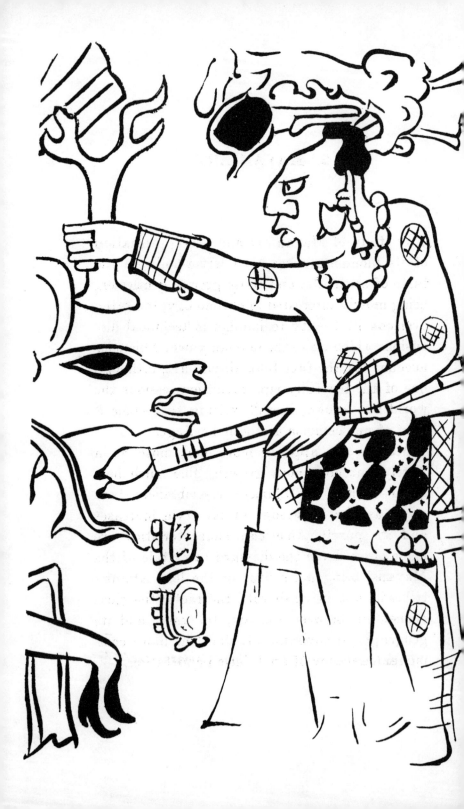

2. MAYAN ART

THE study of Mayan art and the appreciation of its monuments has been left wholly to the taste of scientists, and those precise gentlemen, being mostly interested in chronology, too often overlook its beauty to indulge in technical discusions which make the layman yawn. This may account for the fact that Mayan art, although one of the few fully ripe racial expressions the world has known, is still waiting to become a part of our common aesthetic heritage.

Mayan art appears more and more as a purely autochthonous growth. The much heralded Chinese or Siamese resemblances fade away as our knowledge of its style increases and its purely American characteristics are made clear. Even the die-hard fairy tale of the Mayans' being a survival of the lost Atlantis tribes is less in clash with the facts, the close connection between the art, the race, and its geographical environment, than the more commonplace theory of an Asiatic importation.

17

The layman tends to regard this art as just another of our many American tribal expressions. He does so with the paternal condescension with which the civilized appreciates any savage culture, since Parisian aesthetes started the Negro art fad. But on the contrary, if one possesses an aesthetic flair and a sense of the fitness of respect, one will approach Mayan art much in the same way that a learned Occidental studies Chinese ink paintings or Japanese poetry, considering it as something more subtle than the similar products of our own present-day era.

Its stylistic cycle follows the universal scheme. It started from archaic forms to culminate in a genuine classical purity, then, through the overripe excesses of baroquism, vanished together with the civilization that had given it growth. Just before the end, a reaction of purism or neo-archaism gave birth to some of its most exquisite monuments.

A choice between the diversified wealth of its remains is mostly a question of taste, and taste is a very personal affair. Here again the archaeologist, innocent of aesthetic training,

looms as dictator, and the public, taking his word for granted, knows and admires most the monuments typical of later rococo times. Lovers of virtuosity for its own sake can well take pride in the decadent 'dentelles de pierre' of Quirigua and in the late works of other sites, all of them unsurpassed in the history of monumental sculpture for their confusing amount of carefully worked details. Through decorative spirals, volutes, and curves, men, animals, monsters and gods intertwine their bodies in competition with the surrounding tropical exuberance. By a sort of artificial mimetism, chunks of stone are made to look like corners of a jungle. Let the imagination surround them again with hordes of chieftains and priests in heavily embroidered gowns, with their god-masks, weapons, and ceremonial staffs, and you will not fail to enthuse both theatrical managers and "nouveaux riches". Here indeed were splendors that put to shame even a Roxy.

But Mayan life and Mayan thought were not only this gorgeous pageantry. Their classical manifestations are less luxurious but wealthier in human values. A sober taste guided the au-

thors of the 'Beau Relief' of Palenque, and some eight hundred years later the fresco painters of Chacmultun and Chichen-Itza. On plain backgrounds, personages clad in peplum-like garments move with elegant, over-refined gestures, their slim bodies elongated to the utmost. The artist, as the Greeks had done before him, attempts to summarize his philosophy in the choice proportions of the male form, and stakes all on the human body. But in these works palpitates a spirituality that clashes with the Greek athletic ideal that gave such a rustic health to both men and gods. The quasi-morbid attitude that those reliefs immortalize is still the appanage of modern Mayans. How such languid-looking adolescents were able to build and to keep in working order the complex machinery of their civilization is more understandable for those who have seen Mayan masons lift with lazy gesture, and carry on their heads, weights under which one of our strong men would stagger. In the whole field of Mayan monuments, this group of art works stands the closest to us, being endowed with a psychological flavor that links it closely to our own an-

thropomorphic habits of thought.

But in the Mayan scheme of things, man was far from playing the dominant role. He was a well-nigh useless addition to a universe in which planets, stars, and an innumerable and complex host of gods moved in orderly fashion. To live his life without crossing the way of those mysterious beings was man's main concern. Hence the priest controlled all. The metaphysical subjects proposed by the priesthood to the hired artist were, by a happy accident or a racial affinity, exactly those that befitted his gift. The Mayan artist was most interested in abstractions. The use of line, volume, and color for non-descriptive, highly intellectualized purpose, was as natural with him as an objective fidelity is to the camera. As a result, this art stands as one of the wealthiest mines of theological motives and plastic abstractions the world has ever known.

The simplest and presumably oldest forms of human representation (stela 8, Naranjo) are realistic, with a trend to caricature. The conception, however, soon widens with the growing ability and ambition of the stone worker. The

representation loses its naturalistic appearance, anatomical proportions become distorted, and the wealth of complicated garments and ceremonial ornaments climbs, vine-like, over the human figure, humbling it to the role of a mere peg for symbols. The features remain visible for a time, as the last objective spot amidst this wealth of abstractions, then disappear in turn under a fantastic mask, thus depriving us, the modern onlookers, of even this last refuge for our too strictly emotional appreciation of art. Thus the typical Maya monolith was an encyclopaedia of dogmatic knowledge. Once an accumulator for religious energies, it is now, with its meaning mainly lost, still a foyer of plastic ardor.

That a process of purification modified natural forms into a highly divergent pattern is in many cases evident, the link being as brittle as that between a Picasso picture and a guitar. But another group of art forms must have been born directly from the mind of their makers. Theirs is a more radically abstract language than any of those used by modern artists, and baffling indeed for the scientist who attempts to

pin down some objective model from which such symbols could evolve. One of two groups of equally serious explorers saw a parrot in a detail of stela B, at Copan, the other group, an elephant!

An individual may create a new pot shape or decorate a vase for his own egotistic satisfaction. But the impulse that gave birth to the temples and major sculptures of the Mayas was the collective urge that seizes whole crowds and makes them build as one, be they Athenian Greeks or Gothic Frenchmen. This social art, now that its society has vanished, remains in an enforced idleness amidst its jungle surroundings. As a modern recognition of its utilitarian origin, Indian hunters still make sacrifices of deer and burn copal in wooden spoons at the feet of the carved stelae. Even the white man recognizes dimly that no purely aesthetic appreciation will do it full justice. He tries to complete the picture by scanning the other remains of this civilization, tries to read its written text and discover the spring that caused those monuments to surge as an answer to the need of the people. About a fifth of their hiero-

glyphs have by now been deciphered, but most of these texts happen to be merely arithmetic, dealing with astronomical computations, the movements of the sun, the moon, and the planets. This very lack of sought-for sentimental corollaries is illuminating. The backbone of the art, the mental scaffolding the Maya priests offered to the artist so that he could clothe it with his own aesthetic passion, is mathematical. Numbers, being measure and rhythm, are poetry in a sense, but poetry accessible only to a few. In order to attract crowds it must be clad in less metaphysical garments. This was the role incumbent upon the Mayan artists, sculptors, modellers, and painters. They made this dry, if noble, dogma partake of the richness of the landscape, yet not following it in its disorder, but creating a human tropic of new shapes and meanings. Stela 11, in Yaxchilan, perhaps the most impressive conception ever attempted in sculpture, shows that the artist fully understands his role; here trembling worshippers kneel before a shrine. A miracle happens and the god appears, a frightful god indeed. Behind the divine mask magnificently carved,

the artist reveals to us, and to us only, the pro-
file of the priest who impersonates the god. He
is a dry, shrewd, scientific person, wholly dis-
dainful of the tremendous sensation that his
disguise creates.

The more plebeian art objects are teeming
with a wealth of grinning gods, old gods, black
gods, and even among them the ambiguous
beauty of the Maize God. Thus did the artist
grind food for popular sentimentality, some-
thing to cling to when one ignores mathematics
and yet needs a faith and a morale.

3. A XIIth CENTURY MAYAN MURAL

MEXICAN murals have been much discussed. Both in their physical make-up, the true fresco technique, and in their sociological implications, they have sown seeds that fructify even unto the humblest post offices of the U. S. A. Though this movement has helped American art to a distinct and different status from the art of the school of Paris, people have been most incurious as to why it should have started in Mexico, vaguely imagine that Mexican modern art is a mushroom growth, unrelated to the traditions and monuments of its past. Mexican murals have come to mean those that have been painted in the last fifteen years and few suspect that there is in Mexico a mural tradition centuries old. Though this truly indigenous tradition had been despised through the nineteenth century and humbled to the walls of village chapels and of wine-shops, it can be traced directly to the mural decorations of Aztec and Mayan temples.

26

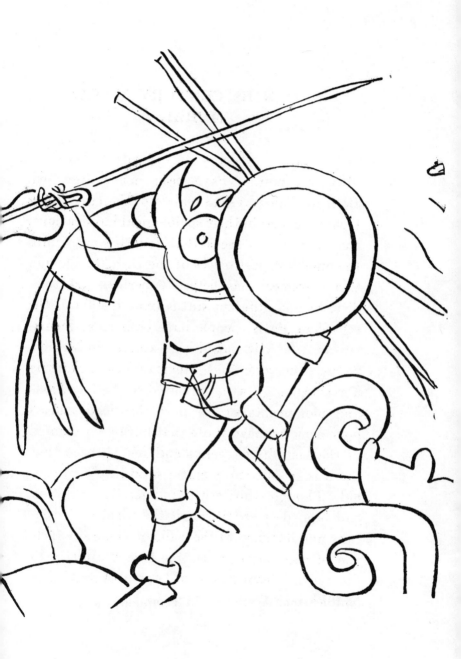

☞"Leaping Warrior." In Temple of the Tigers.

We gain an indirect knowledge of Mayan murals, those of the Southern school, only through the potteries painted in monumental style and the low bas-reliefs carved or stuccoed in temples, which, in their heyday were thoroughly polychromed and thus more paintings than sculptures. Frescoes proper could hardly resist the jungle dampness. But from the so-called New Empire of the North we still possess some important remains.

The Temple of the Tigers is a small edifice which dominates the ball court in Chichen-Itza, Yucatan. There players and judges probably went to pray for victory or there the victorious team received its prize. Though the national game combined some features of football and basketball, this chapel served a similar purpose to those chapels in Spain, annexed to the arenas, where bull fighters kneel before they kill. Its age has been computed as dating from 20,000 B.C. by the enthusiastic and unreliable Le Plongeon who saw in its paintings the source of all Egyptian art. Hard headed German scientists claim it to have been built but little before the Spanish conquest. It is more probably of

the twelfth century, being one of the oldest monuments in this New Empire metropolis. Whatever its date, it contains most perfect specimens of Mayan painting in its inner chamber, depictions of peace and war, religious ceremonies, apparitions of the gods. Their line and color were still brilliant enough in 1842, when Stephens and Catherwood rediscovered Chichen, to make them exclaim that here was the Sistine Chapel of the Mayas.

Of the seven panels which constitute the decoration, the best preserved today is at the right of the inner door. The painting has suffered to some extent. Much of the last coat of paint has flaked off, uncovering a preliminary tracing in light pink, only faintly visible against the creamy ground. Souvenir seekers have done their work of destruction, travelers have inscribed their names or scribblings since prehispanic times. On account of this, a patient study through careful tracing does more justice to the work than does direct photography. A copy of the whole wall traced directly from the original by Mrs. E. H. Morris and myself in 1926, and unpublished up to now, is the basis

for the illustrations of this article. Its line matches stroke for stroke the one that the artist traced on the wall before covering it with an opaque pigment now gone. It does not show the picture as it was when finished but as the first draft which was to be amended and illuminated later. As is the case with most sketches, although it has not the perfection of the completed work it shows more spontaneity, makes us commune more intimately with the mind of the artist.

The technique employed is complex: the wall itself was of carefully squared and joined stones on which a first coat of rather rough-surfaced lime was spread. On a second coat, as smooth as paper, the preliminary sketching was done in true fresco. The brushes must have been long, pointed and fat as are the Japanese brushes, which alone can explain the flexibility of line and the quick variations of thickness. In this first phase of the work, the artist sought rather the balance of masses than a detailed story-telling. It must have been to him something of a daub, as great chunks of wall were covered at one sitting. The brush, vigorously wielded, has

left many spatters of the too liquid tone, most visible on the lower areas. The line is of a very pale madder red, of transparent quality, and includes corrections of posture, anatomical indications under the garments, changes of mind concerning accessories. When the line had been traced, the background was filled in with terre verte, also in fresco, and the local colors of people and objects were lightly sampled in a water color effect. When this part of the work was dry, another technique was put into use. The painter instead of using a liquid color changed to a pigment of much body, a kind of thick tempera which admitted of more depth and variety of tone; over the fresco proper was spread this new set of colors of a density and intensity of enamel, the most conspicuous being a cerulean blue, a mauve and a Veronese green. Those and also a thick gouache whiter-than-lime mixture were spread over the frescoed wall in absolutely opaque coats a sixteenth of an inch thick. The adhesion to the wall was not as perfect as that of the different coats of lime to the stone, so that much of it has now peeled off, uncovering the preparatory sketch. The last step in paint-

ing consisted of filling in the details on those
colored silhouettes, inventing new lines where
the first one had been lost and, where it was still
to be seen, interpreting it freely with black. The
result is most original: the pigments play not
only through color but also through texture,
transparent or opaque, albeit some of the fres-
coed part remained uncovered, especially on the
backgrounds. The painter having massed in his
composition in the first sketch, could in the last
rendering go to the extreme detail without los-
ing the balance of masses.

Between the floor and the level of the paint-
ing proper a decorative dado was painted, rep-
resenting Atlas-like figures up-holding the lower
edge of the picture, amidst water lilies and fishes
silhouetted against a dark blue ground. The
painting proper is square in shape, covering an
area of a hundred square feet. It stops at the
left in the northeastern corner of the room; at
the right it butts against the stone jamb of the
door, on which is sculptured and polychromed
a standing warrior. The lintel of this door, a
beam of hard wood, cuts deeply into the square
itself. The subject matter is that of a battle

being fought on a field which spreads between the raised tents of an army and the thatched-roof houses of their foes. The composition divides itself naturally into three bands, the upper one being the village, drawn as a background to the fight. The men have gone to the battle, the women busy themselves with provisions for the warriors, a few old men and women squat on the ground or on roofs unmoved by the goings-on around them. One warrior is seen in an interior, the atl-atl or spear thrower held in hand, either coming from or going to the battle. An important looking elder person, in which one would be tempted to recognize an in-law, seems to criticize his action strongly. This creature sits between the soldier and a young woman, probably his wife, who offers him a drink from a cylindrical jar. The eternal triangle is suggested by a good looking girl, a neighbor, who signals to the young man from behind the back of the other two, with an offer of food in her lap. To the left a woman with a load on her back, going towards the front lines, turns toward the group and waves an adieu. The artist has strongly emphasized the archi-

tectural quality of the houses so that at a distance the human incidents become plastically negligible. The verticals and horizontals of the buildings mark this whole upper part of the picture as static. This painted area stops at the lower line of the door lintel, a proof that the artist made his story-telling subservient to its architectural surroundings.

We come now to the battle proper which covers two-thirds of the whole picture. More than a hundred soldiers are engaged in individual combat or roam in small aggressive bands under the command of two chieftains, each being silhouetted against the coils of a plumed serpent, his own tribal god. The multi-colored implements, the bodies of burnt umber carry well against the light terre verte of the field. The soldiers display round shields and long javelins. One of them is dead with a spear through his thigh. Though the scene is one of extreme agitation seen close to, the more one recedes from it, the more a kind of secret order emerges.

The artist has played a masterly game of geometry, using as units the circle which is the shield and the straight line which is the spear.

Both elements dovetail into a series of pyramiding forms, the lower ones more obtuse, the higher ones sharper. All those diagonals surging upwards from the outside towards the center bring a compositional order the more admirable for using as its means the very excess of action depicted. Each individual drama cooperates into constructing this ideal pyramid which is the hidden goal of the artist. Only two men hold lances horizontally and those are placed at equal distances from the horizontal middle, substantially at the place where the golden sections would be, a unique proof of the universal aesthetic appeal of this venerable proportion. Rows of trees on both sides of the battle field chart its topographical area as being identical with the actual area of the picture.

This most dynamic battle scene is sandwiched between the architectural presentation of the village already described at the top, and a corresponding strip of static content which is both the lower part of the picture and its intended foreground. Among semi-spherical tents, martially adorned with feather and canvas standards, chieftains are quietly seated, engrossed in

negotiations. It is again a calm composition, plastically speaking, the counterpart of the village, its immobile personages accentuating the extreme action of the fighters. Boldly rising from this lower part far into the very field of battle, two unusually high standards are topped by an apparition of the senior god. He presides at the negotiations from his abode, a solar disk fringed with resplendent rays. Because of its religious import, this vision is the spiritual climax of the picture, but also through the artist's choice of the long, straight banners tipped with the concentric circles of the sun motif, it proposes and amplifies the two plastic units which recur in opposition all through the picture, the straight line and the circle, the spear and the shield.

Though we possess many precious remnants of Mayan murals, this is the only composition which has come down to us whole. Its geometric scaffolding, the elasticity of the symmetric themes and moreover the ease with which all calculations efface themselves to let us enjoy the vivaciousness of the story-telling make of it a model composition comparable to the best of

whatever age or country.

Art historians would have a tough time trying to fit this mural within the iron corset of their classifications. In its absence of modelling, of cast shadows, of atmospheric perspective, it differs from our own realistic school, being closer to the conventions of the Near East. But the landscape suggested by the simplest means, a few trees, some waving lines to suggest a hilly ground, is a mere device, a pedestal to make more prominent the human body displayed in many attitudes. This lack of interest in natural spectacles, this focusing on man, shows a very different mental state from that of the Orient. It leans to the Greek, whose line drawings on vases are also stylistically very near to the drawing of our muralist. But we lack here the godly postures that man strikes in Greek art; here the keen observation of familiar details, the good humor and quick action remind one, in spite of a different plastic language, of a Flemish picture à la Brueghel. Mayan art defies any label.

The human figures heaped on top of each other no more suggest recession in space than

do Egyptian bas-reliefs, but while the Egyptian would at least have had them all of the same size, here, the more they recede the more they increase in scale, a most unusual effect to an eye trained, as ours is, in the postulates of Italian perspective. The chieftains in the foreground, drawn directly over the dado, are less than half the size of the warriors that are to be seen behind the houses of the village, perhaps a mile off in space. This puzzling feature is yet a proof of the scientific care that the artist took to fit his mural to the problems of architecture and point of view. The room is narrow enough so that one squatting, as one was intended to do, would find those lower personages on his horizon line and close to his eyes, but would get a more and more diagonal view as his eyes moved up the wall. The increase in size of the personages at the top is corrective of such a condition, and gives a squatting man the illusion that all people depicted are the same size. Similar optical correction to an intended shape has been found by Dr. Spinden in another temple, its principle being an elongation of the verticals. It was the same prob-

lem that confronted El Greco in some of the narrow chapels of Toledo and it called for a similar solution.

To the narrowness of the room is also due the choice of a minute scale, the figures averaging some ten inches high, which carries well at close range. The only exception in the chamber is on the opposite wall, a central panel facing the door which would be seen through the succession of rooms and even from the other side of the court. Only two figures are painted there, and those of a heroic size, again a logical solution of another problem in point of view. The painter was also interested in the illusion of movement: a file of warriors in action are in reality the same man seen through different phases of one gesture, as happens when we look at a cinematographic film unrolled flat. The time that the eye takes to move from one posture to the next equals the actual time needed for the bodily shift.

The "canon" of human proportions is similar to the late Greek, being six or seven head-lengths to a body. However, the art fashions of the time must have been as quickly changing as

ours, for this elongated appearance which we identify as "refined" gave way within a few generations to a different one which we see displayed in the neighboring Temple of the Warriors. There the painted people, as in much Negro sculpture, have a height of some four heads to the body, which to us seems 'primitive' or 'barbaric.' Was it one of the adepts of the new school, incensed by what he thought was an absurd elongation in the older fresco, who went so far as to scratch into the beautiful painting the figure of a little fellow which exemplified the new art? If so, the layman of the time must have deplored the lack of respect that youth showed for the art of such a recent yesterday, and grumbled in front of this squatty graffito that painting was going to the dogs.

This gloomy talk came true. The "little people" painted in the Temple of the Warriors seem to have been a last show of vitality within Chichen-Itza. When the Spaniards entered Yucatan in the sixteenth century, not only Mayan art, but Mayan might had crumbled. The jungle had reclaimed the city.

4. MEXICO OF THE POOR
1922

I HAD staged in my head a sham Mexico, fanned with feathers of blue, green and red, its trees feverish with tropical mimics. I somehow felt cheated after landing, in spite of the guided tours, the marble bulk of the National Theatre, the powdered maidens dressed in organdy, the gentlemen sunk within stiff collars. One of the latter, as wealthy as he was senile, said: "No equality is possible here; decent people and wild men." I was soon to find the truth of his assertion.

At six o'clock in the morning, I was in the streets. Automobiles and ladies were still asleep, and the true features of the town emerged, washed of this phony coat of paint which disfigures it in the day light. Beautiful beings people the street like Ladies of Guadalupe innumerable. They move noiselessly, feet flat to the ground, antique beauty come to life. The wealthier quarters are as empty and soiled as a music

hall at noon, but everywhere else, among those low-lying houses, cubic and freshly daubed, processions are staged. At a first glance the crowd is the color of dust. Flesh and cloth, both worn out with use, melt into this grey which is the very livery of humbleness. Eye and mind soon learn to focus, and this race, its confidence won, attests its beauty through its fabrics, its straw, its flesh.

A shy taste has chosen for blouses and skirts designs not of contrasts but of neighbors: grey on grey, black on beige, pinks and wine reds. The rebozos are of all shades, so subtle that an impertinent eye can not distinguish between them: blacks and greys, tans, blues, from the nocturnal blue to the tenderest water color wash, pigeon-breast, with fringes that master the theme with coarser contrast.

As a broken wing, so is an empty rebozo. It lacks the fluttering, the living folds that the enclosed head makes, even when unseen. From the back, twin braids often appear with a purple wool braided in, and the arc of the shoulders melts into one body and cloth. Front view, the oval or the sphere of a face, its ochre pigment

an equivalent of the cloth, deepens by contrast to the white of teeth and eyes. There are many ways of wearing a rebozo, all noble. It will only yield the most essential folds, functional resultants of the body in action, as do not those imported stuffs that frizzle on one, poodle-like. The maidens of the Parthenon would accept as sister any one of those shoeless Indians. Same gait, same gesture, the print of the naked feet on the earth is antique, the sole clinging horizontally to the ground, tactile as a hand, and the trotting step of the peasant women, foreheads slit by their burden, inclines their torso diagonally like those ancient Victories bestowing crowns. Or, the belly armored in a robust sash, the shirt stretched by the young breast, there is an Egyptian narrowness of the hips, with the arms hanging at ease, unconcerned with the weight on their shoulders of a bundled baby asleep. The patting of the dough by 'tortilleras' re-echoes in the hypogeas of the Nile. Wrists and ankles are small as those of a child.

Blessed be the cold spells when the man wraps himself into his sarape—a peplum! He would be a tribune on a pedestal, if the hand-woven

cloth did not seem even more perennial than
marble togas, and heavier. The colors of the
sarape vary but could be summed up with a
white, a beige and a black; most beautiful are
those plain ones whose shade and texture imi-
tate the scarce fur of over-burdened donkeys,
some white threads mottling the grey as the
hair grows on the scar of a wound. The sarape
needs a body. When hung on a wall, tourist
fashion, its slit yawns like a neck beheaded. As
in Brittany, when the young widow draws from
the chest a sweater still bulging from the pres-
sure of dead shoulders. Those that the tourist
treasures are loud with parroty designs to
warm his barbarian heart, but the weaver will
not wear them, and the wool soaks into such
dyes gingerly.

The head closes the sarape, the hat crowns
the head. Of many straws, from those thick as
slim bulrushes, whose open basketry rains sun
spots on the shoulders, to those which, ribbon-
flat and green, still keep a suppleness of living
leaf. Of all shapes: circular as haloes gathering
the light as does the underbrush, light as wings
to which the rhythm of the march communi-

cates flight, some thick and embossed, reminiscent of breasts and of Babels, the hieratic ones like the tiaras of disused rites, the earthly ones whose handiwork of embroidered leather spells the prosperous cattleman. All, geometrically beautiful, isolate the head from the landscape, its psychological worth intensified within this vacuum.

This race has the wisdom of the philosophers who walked with naked feet in a stream while abstracting ideals. Its toys have the twist of Aesop's fables, its bodies the patina of those antique athletes of whom Lucian states that they are like sun-baked bricks. When the servants troop out of the earlier Mass, the repetitious beauty of their naked feet, the ample petticoats, the draped scarves, duplicate the rhythm of the Panatheneas. Greek vases parade into life. Here the women bringing water from the well, there the wrestlers of Euphronios, and at all street corners or in the shade of a statue, beggars and burden-bearers, squat and loiter at ease, gorged guests of an invisible banquet.

Rebozo, sarape, flesh and hair partake of those shades which are the palette of Nature:

yellows, reds and greys of earth colors, the blue-greys, the grey-blues, and as a climax those changing colors of the pigeon's throat. I arrived with good chemical colors bought in France, ready to match monkeys and palms, as an explorer carries gaudy calicoes to do barter. How could they stand for these, the very colors of water, earth, wood and straw. Even my up-to-date theories of art must go over-board, as I face the features of this land truly secretive and classical, whose perennial mission seems to be the apotheosis of the poor and the scandal of the impertinent.

5. AESTHETICS OF INDIAN DANCES

THE quality of the preserved relics of pre-Spanish civilizations—sculpture and architecture—suggest a similar beauty for the more ephemeral manifestations of their art: painting, music, the dance. Even after a few centuries of forced contact with European culture, we can still watch some mutilated reflections of what they were.

Our own 'civilized' dance proceeds as a pantomime of sexual gymnastics. The Indian dance is the fruit of a taste based on a comparison of proportions, a quasi-mathematical precision that has very little to do with what we consider pretty.

The dance, at once an optical and a musical spectacle, participates of both arts. As in painting, its essence is in simultaneous relations of shapes and colors independent of the time factor. As in music, it proceeds by successive steps bound to a time element. In the Indian dance, the permanent elements constitute a kind of

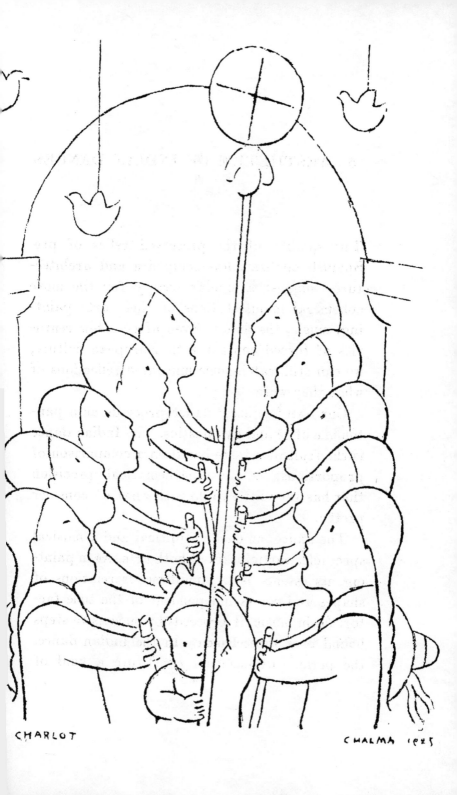

CHARLOT CHALMA 1945

☞ **"Dance of the Pastoras in Chalma."**

stage upon which the fugitive ones parade. The ephemeral and brittle essence of motion is emphasized by the use of wooden masks and rigid armor-like costumes. A new kind of beauty is born out of this relation of contrasting neighbors.

The mood of the dance varies from the grossest slapstick comedy to the highest and most rarefied religious emotion. Its only hiatus is that it never treats the sexual theme, even indirectly, as if by common consent such a doubtful job had been delegated to the whites. The Indian possesses an instinct of style which, omitting the realistic mimicry inherent to a given emotion, transposes its essence upon a higher plane where it is digested and reborn into a series of plastic proportions. The white man, impotent to choose between a number of photographic attitudes that fit a theme, ends by omitting none. This results in a hodge-podge of bodily movements that tire physically both dancer and public, a sweating sport that precludes a more spiritual fruit. The Indian takes an agglomerate of movements, sums them in a composite so meaningful that the single gesture consti-

tutes a whole dance. In the ballet of the Magi, in Michoacan, only one of the three kings does perform, only three slow steps does he take, yet they conjure the mystery of this legendary cortege and the prophetic belief that started it on its way. In Chalma, the vivacious tempo of the "Gachupines" (dance of the Spaniards) so unrelated to the squat, slow moving Indian body, is a plastic illustration of the mediocrity of certain white men who talk too much, act too much, believe too much in themselves, lack a central core of faith.

Other dances are reminiscent of mystery plays, include a libretto and complex stage directions. A pre-Spanish type still in use is the hunting dance of the Yaqui. The dancer-prey mimics the despair of the animal at bay with a nervous pendulum movement of its antlered head, while the dancer-hunter fires a rasping noise by rubbing two notched sticks, a more telling menace than would be the actual popping of a blunderbuss. Discreet mathematics rule pathetic moments. In mock battles, whose fury seems true enough to the eye, a clash of sabres rhymes with the musical phrase. In a

dance of Santiagos, the Arab chieftain, alone
fighting six Christians, falters into a spiral of
steps that recedes to a center where, the geo-
metric figure completed, he falls dead. The In-
dian will express emotion rather through num-
bers and figures, for he has a born repugnance
to using the tool par excellence of the white ac-
tor, his features. A painter of Antiquity was
lauded for having veiled the face of a figure in
a tragic moment for, remarks the Greek text,
"it would not be possible to represent directly
such situations without indecency." Thus, when
the Arab chief enters in agony, far from con-
torting eyes and mouth, he covers his face with
a kerchief and it is only the slowing-down pace,
this melancholy of the spiral shrinking its ray,
that testify to the drama at hand.

What makes the strength of such panto-
mimes is that they do not mistrust the natural
gesture. They stylize it, amplify it so as to
further its optical range, never debase it into
gesticulation. Because of this conformation to
truth, such dances may utilize one of the most
moving but also most brittle of means, the in-
nocence of children. Childish quadrillas, pas-

toras, malinches, keep intact those deep infantile qualities from which the most able of our ballet masters could extract only cuteness. Those children-dancers do not ape grown-ups as do our juvenile actors, the gesture starts and ends with little accent and much hesitancy, a plastic cipher for those sheltered souls whose contact with the world is still amateurish.

Unlike our professionals, riveted to the level of a stage and its inverted lighting, the Indian dances inside churches by candle light, in the sunlight of outer plazas or amidst mountain scenery. He uses a variety of levels, mingles in the street with his public, is raised a few feet by improvised scaffoldings, perches in this hut on stilts, throne of the Tepozteco, flies to stratospheric peaks with the gymnasts of the Volador.

Our dance clothes the dancer to emphasize the human appearance. A woman, for example, gambols wrapped in veils which underline her femininity and exasperate the mechanics of desire. The Indian costume and mask have a contrary aim, they remove the dancer from bed level, place him in an abstract atmosphere suggestive of the entity which he symbolizes,

even if to gain this end the man has to be an-
nihilated, transformed into a kind of animated
glyph. The face remains impassive, be it the
features of flesh or a carved mask. With its
dovetailing plates stiff and squared, its un-
natural proportions, the clothing attains more
vitality than the body buried in it, lives its own
life. The dancer is no more than a cog in this
complicated mechanism of the dance.

The ingenuity of the Indian in his handling
of the human dummy is diverse. Not only will
the face be hidden behind a mask, but it loses
its place as the apex of the human pyramid, is
humbled under those elevated coiffures whose
parasol of mirrors, tin and feathers suggest
the palm tree as our high hats reminisce of the
chimney. Toe-dancing elongates the leg, knee-
dancing amputates it; the hugeness of belts and
bracelets increases the hips, or destroys the sym-
metry of limbs. The masks are not the psycho-
logical masterpieces of the Japanese No; they
abuse the head ruthlessly, shrink it smaller than
nature as do those of the Yaqui, make it larger,
or double-faced, armed with huge horns which
give the dancer the barbaric aspect of a stand-

ing bull. To the Indian mind horror is also a form of beauty, which makes them partial to the carved semblance of white men. Pink cheeks, blue spectacles, red beards trimmed Spanish fashion produce on their brown public impressions of laughter and terror similar to those indulged in by our children when they see masks of black or green devils.

Modernism has reopened for us abstract sources of beauty, cleansed our aesthetic sense of a too pervading sexual content, made us prefer to dramatic mimicry gesture as conjurer of geometry. We own anew the keys to the aesthetic of Indian dances. Alvarado, to have massacred the participants of the Flower Dance in the Great Temple, must have been a soldier impervious to artistry, or the incensed addict of racy and photographic art.

6. THE INDIAN WAY

I

THESE cuts are details from a catechism in hieroglyphs of the sixteenth century, from the Von Humbolt collection. They illustrate articles of Faith:

1. Our Lord dies to save sinners.

2. He goes into Hell and delivers the souls of the Patriarchs.

The strength of pre-Hispanic art animates those scenes, in spite of the imported theme; which points to the casual role of typical subject-matter in the creation of a national art. The keenness of proportion and ease in abstraction here shown still live in contemporary so-called popular arts.

II

In Oaxaca, one may buy for a few cents a child's game played upon a paper checkerboard emblazoned with hand-painted designs: hearts, pineapples, suns, cacti, umbrellas, skulls, roses, scorpions, straw hats.

One of them is the puzzling motif here repro-
duced, which may be identified with Veronica's
kerchief, a devotion widely observed in this re-
gion. It is enlightening to follow the stylistic
process by which the Face of Christ becomes
one with the napkin. The features are drained
of sentimentality, the folds of the linen become
serpentines, the rosettes at the top pennaches.
We surprise here in its creative motion the In-
dian's genius for plastic abstraction. He will-
ingly accepts our ways, if allowed to make his
own interpolations.

7. 'PULQUERIA' PAINTING

I KNOW some cultured Mexicans who cruised to Egypt to see the Pyramids, but never took the bus to their own pyramids of Teotihuacan. Touring through Italy they go to Pompeii and rightly admire the murals which adorned the shops of bakers and wine merchants of the first century A.D. How supremely refined this Roman civilization to leave such remains, to create works of art out of commercial posters and graffiti scratched by drunken soldiers. The tourists sigh, thinking such an era well dead, such art a prize for museums only.

Little do they realize that their own country, this Mexico of today, has more than one trait parallel with the Roman resort. Much as in Pompeii, bad taste piles up dubious furniture, exasperating objets d'art in the palaces of the wealthy, while good taste goes into the ornamenting of the small shops, bakeries, wine shops of the poorer quarters. The rich thrive on alabaster statuettes, Louis XV pianos and tele-

phones in the style of Louis XVI. Poor people, who can afford only what they make, enjoy creations of a sturdier health. The theory of art for art has not touched them. Pictures must have a definite reason to be: devotees bribe Saints with ex-votos, lovers melt the heart of the beloved with a portrait, artisans, merchants, hire the painter to beautify their shop with murals, and thus increase the business. Sculpture also exists for specialized aims: dark ones, idols of secret worship, semblances used for black magic; innocent ones: those marvelous toys worth a few cents, beautiful as Han tomb figures. This production is so varied as to be unclassifiable, so cheap as to be despised, so near us, so thrust under our very eyes as to become invisible. Yet, when those who create such objects are dead, when the wear and tear of constant use has made them rare, those items will rest in show cases as do today the similar humble objects of Etruscan or Chaldean sources.

When 'cultured' people paint or sculpt, their very lack of specific purpose is lauded by those who approve of mandarin nails which make the hand unfit to toil. But for the man in the street,

those canvases and bronzes should be an example of what not to do, similar to the slave that the Roman master would make drunk to show his sons the repulsiveness of vice. Art for art is a bad enough slogan, but it is a front for even baser things, this love of money which concocts best sellers, this smugness of the man curled up within his originality, this pride of having learned so many incompatible things that we have lost faith in each. We would like to believe that what walls we have painted, what pictures we have frescoed, constitute what newspapers have dubbed a Mexican Renaissance, yet there is this disturbing fact that through the centuries, in unbroken and magnificent routine, popular artists have carried on a Mexican tradition which has been and is in the best of health. Such artists do not pride themselves on their doings, could not give interviews, yet Mexican art is alive enough to mar somewhat our assertion that in our works it is reborn.

The true show of art is in the streets, ennobled by the murals on the walls of grog-shops. Their themes are varied as are the very names of those "pulquerias". What ingeniousness must

a painter have to illustrate "The Memory of the Future", or "The Wise-men without Study". The muralist does original work if such be the wish of his patron, but unlike his cultured colleague, he is original in all humility. When his fancy turns to doing an extra good job, he copies some foreign work, Swiss landscapes, post cards of the World War or German chromos. Though partial to Aryan women of pink skin and flaxen hair, his work remains more Mexican than those brown Indians that I insist on painting.

In those works, descriptive subject matter exists side by side with abstractions; walls bulge or sink, peopled by make-believe solids and multi-color planes. A flat surface is camouflaged into receding niches or buttressed with illusive columns. This solution in depth of the decorative problem would annoy Puvis de Chavannes, whose painted walls make an effort to look as flat as if they were already whitewashed.

Such wine shops, butcher shops or bakeries with façades and interiors excitingly frescoed are a practical answer to queries as to the whys of art. A writer proved the use of poetry by

declaiming to his cook; moved by the verses, the cold hearted woman had to yield. In the same way does the picture invite its public. More patrons will get drunk in a wine shop well adorned, thus proving the reality of art. Nor is it by pleasant subject matter that the charm is woven, but by line and color. The story itself remains incidental, may even be of a disquieting nature, as in a butcher shop of la Piedad, on whose walls cows and pigs busy themselves with quartering, cooking and eating the customers of the establishment.

It is too bad that people of good taste will not take notice of the art show in the streets. More than museums and art galleries, the streets of Mexico are an index to its culture.

8. ON THE COMPLETION OF RIVERA'S FIRST MURAL

March, 1923

THIS man has erected amidst small intrigues and petty vices, those monolithic breakwaters, this battalion of Virtues with its insignia and assigned duty each, unwinking sentinels guarding the glyph of God.

Bureaucrats have paraded their white ties in front of this majestic page. They say "Very good, but somewhat expensive." The painter is accused of extravagance, of skipping working schedules. He does not answer but, with hermetic bitterness, climbs back atop his scaffold, for he is a worker with every day a day's work ahead. Queer planet, ours. Why are the prophets stoned.

Take patience, you will die. So will those ministers and cashiers. Your thought will be voiced tomorrow clearer than today, for the dwarfs will stop their bellows. This wall will witness comical scenes, lay processions, guide book in hand, gaping in awe at the Old Master. Ciceroni will earn their penny. Statues will

perpetuate this flesh of yours in the rhomboid shape it had. You will be well-haloed, subjected to political speeches and art historians. Meanwhile pursue your task. You have enough wit to manoeuvre your heavy shell, enough philosophy to be flippant.

Our trade differs somehow from the carpenter's and the roofer's. People do not agree to its good or bad; we alone know. To paint is a trade, but good painting is more of a virtue, persecuted as such for useless. We must grumblingly join the ranks of the martyrs; when we die and the feast begins, white robes will be slipped over our maculate overalls. This repast may turn to be an artist's picnic, misers and potentates preferring the outer darkness.

☞Pouncing sheet for Rivera's first mural.

9. POSTSCRIPT TO A DESTRUCTION OF FRESCOES

August, 1924

Non intrabit eunuchus, . . . Ecclesiam Domini.
Deut. XXIII, I.

THE murals of J. C. Orozco and D. A. Siqueiros, even though unfinished and the painters still at work, have been stoned and mutilated by a group of students of the school on whose walls they are being frescoed. Newspapers and magazines have reported the event as if it was a jolly joke; the kick of the ass to the dying lion was given with fervor by a young poet whose connoisseurship is deficient enough to say that Orozco is a follower of Diego Rivera. As artist and as adolescent, he could have used his energy in behalf of a more generous cause. We will give the community the benefit of the doubt and say that those who succeeded in this wholesale lynching of art works, were students refractory to studies. Though they do not know it, they acted according to a sort of unholy logic, as

71

did other moronic minds which remain branded forever in the pages of History.

Much as the painter wishes to be considered a workman, it is true that his craft differs infinitely from other manual crafts. No solid citizen may question the usefulness of a piece of plumbing well soldered, or of a wall plumbed straight; between him and their worker a mutual respect intervenes, based upon the laws of production and consumption. Such professions are of this world, inasmuch as they contribute to its cosiness.

In the same way, bad painters come within the scheme of established things. Their style, subject matter and mood are in function of a demand. For patrons whose souls have poetic leanings, a painting of flowers hath charms. Less dainty folk can still be tickled by a peep at the inside of a harem bath. Such pictures are haloed with righteousness in the eyes of people law-obedient and of good taste. So popular are they that, minus their veneer of art, they are scratched on the wash room walls of our schools and even our ministries. This kind of art is above-board, obeys the laws of offer and

demand as did the work of mason and plumber, acquires social statute.

But when we consider painters who create their work with a straight intent, unwarped by any commercial lure, whose painting has been shaped by laws as unfathomed and painful as those which rule the birth of man himself, we come socially face to face with the unknown.

To be complete, a painting must be a channel for an idea, as language itself should be. But we know by past experience that whether it is hated by its public, does not depend on the ideal expressed, but precisely on whether it is good painting. Habit and sloth accrue to things known long and well. When a pioneer creates a novel standard of beauty, it clashes with those already labeled and embalmed. If the work transcends an average instinct, it becomes an insult in spirit and letter, for, to contact it, one must look upwards. It is also a creation, and eunuchs never look with favor on virility.

One cannot explain the true painter in everyday terms. He sometimes works for a salary, but more often without. He is alien to a world where activities are spurred by the profit mo-

tive. Nor is painting included in the list of things necessary, as compiled by those sages who know that "man lives only on bread." Good art exists rather on a spiritual plane, must experience disdain as do those other anti-social virtues of humility and poverty which are for their devotees a sentence to suffer and often to die.

This stoning of frescoes is but a link in a chain of similar events: the equestrian clay model of Leonardo shot to pieces by the arquebuses of drunken mercenaries; the Sistine Judgement condemned by Aretino in behalf of moral conventions; Rembrandt bankrupt; Gauguin poisoned, hiding in the mountains with the hope that ants would devour his body. The work mutilated is important, including as it does the admirable "Saint Francis helping the poor" of which no man could in good faith deny the grandeur.

What could the authorities do? What they did: stop the work in course, punish the painters for having attempted to bring beauty to those who have no need for it. Those great works, unique of their kind in the art of today,

may be hastily whitewashed, a monument to the feigned candor of those unjust judges. Will they beautify those walls by having their family photographs enlarged, to mirror and multiply, to the satisfaction of their sentimental bellies, the very image of their fruitless lives and of their immortal mediocrity?

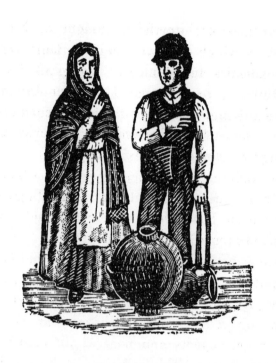

10. MEXICAN PRINT-MAKERS
I: MANILA

In this land where artistic production is the
norm, as in other countries commercial enter-
prise, art is perhaps underrated. Terra cotta
statuettes as great as Tanagras sell here for a
dime, ex-votos equal to the most precious Italo-

Byzantines are worth the weight of the zinc sheet on which they are painted. Duly trained in academies and refined by the expensive trip to Europe, professional artists could hardly make a living, unless the dangerous competition of the masses be challenged. For centuries it was enough to state that Mexican arts were done by poor Indians, thus socially inadmissible, but lately, because of revolutionary rumblings, such an attitude has become precarious and a more involved excuse has had to be found.

None deny the excellence of the indigenous output, but admiration itself has become camouflage. A generic name of 'popular arts' has been coined by which much ado can be made about art-objects and none at all about their makers. Against this nameless background, the signed and dated work of the academician may retain its ugliness, exclusiveness, and price. To de-popularize plastic creations, to give their authors the respect and recognition they deserve, only good faith is needed. In the field of graphic arts we may with little research single out the case of Manuel Manila.

Print-making in Mexico does not proceed by

limited editions or foxy selling schemes. It is
narrowly linked to the penny pamphlet, the
rhymed "corrido" or the prose "relato" which
it illustrates. In Colonial times Mexico received
such sheets from Spain, of which a collection
dated 1736 exists in the National Museum. But
the mestizo did transform such models, as he
had already put Spanish santos to somewhat
heathenish uses. This Mexican style came to
maturity with Don Antonio Vanegas Arroyo,
circa 1880, when his staff of reporters, poets
and artists, published works so homogeneous in
style, so beautifully attuned to race and land,
as to be almost immediately classified as anony-
mous.

One of his first draftsmen and relief-cut mak-
ers was Manuel Manila, native of Mexico City.
Their collaboration, started in 1882, resulted
in some five hundred prints. Manila carved on
metal, with the whites scooped out as in wood.
Like Blake, the artist was his own engraver, and
used this opportunity which poverty gave him to
compose with his tools, white line on black,
within the logic of the medium. A few original
blocks still remain on the shelves of the old

printing shop; others were smoothed into nothingness through excessive printing; most were looted by thugs with an artistic flair, in a number of political raids aimed at wrecking Arroyo's outspoken presses.

Manila's work possesses a personal mental climate, a class-consciousness of its own. It does not hammer social lessons with political slogans and fighting postures; this attitude of a man who makes art for the people is an attitude of leader to led, creates an unbridgeable gulf between both. It is rather art by the people, the worker seen both at work and play, surrounded and explained by his family. We cannot picture Manila snooping with open sketch book among popular rejoicings or dramas but rather laughing and weeping at his own. We find reflected in his prints Mexican characteristics, the love of love and war, the chumming with death, a familiar give and take with a spiritual world, the disdain of money which give a Franciscan hue even to the deeds of Mexico's bad men. Women wrapped in rebozos, tradesmen surrounded by their wares, workers and their tools achieve in his work nobility, reserve, and a pa-

tient knowledge that complaints are not as constructive as action.

Degas said that in art nothing must be accidental, that in painting even movement must have permanency. Such a stylistic peace pervades Manila's work. When he depicts populous market scenes, the trotting gait of burdened carriers, the exertion becomes a symbol, as does the peculiar immobility of high speed photographs or of Seurat's drawings. He opposes static elements as a kind of architectural back drop to dissymmetric ones suggestive of motion. In his print of "El Volador", the verticals of railing and columns emphasize the activities of burden-bearers, vendors and buyers. Benevolent devils kidnapping gay blades fly diagonally across the imperious geometry of a landscape of cubic houses. In a circus poster, a juggler tosses dissimilar objects, bottles, balls, a cannon. He is caught at a moment when all are whirling in mid-air, the gun on the right balances the smaller objects huddled on the left, a poised instant out of a dynamic whirl. When his subject is itself static, as in the group of the water vendor and his wife, Manila attains

as much monumentality as a two inch square
admits.

For ten years his art did service through tens
of thousands of penny sheets, peddled through
fields and cities. In 1892 he stopped working
with Arroyo, shifted probably to another man-
ual trade, little dreaming that print-making
differs in kind from carpenter or mason's work.
He died in '95, a victim of the typhus plague.

When Manila met his Judge, if he did think
at all of the work left behind, it must have been
without bitterness, with the contentment of

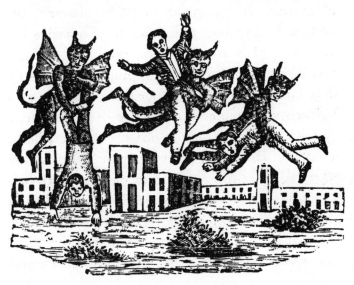

having pleased, stirred and immortalized hundreds of people as simple and wise as himself. He will not puzzle at this aesthetic yard stick we apply to his work, nor will he relish this certificate of artistic glory, for art critics, before they throw bouquets, make sure they will fall on a grave.

Posada: "The Proposal." ☞

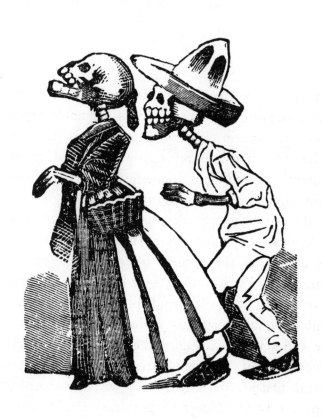

11. MEXICAN PRINT-MAKERS
II: POSADA

MEXICO is aesthetic to the core. Mountains, huts, cooking utensils, fabrics of noble folds, clay toys attain classical beauty. Against such a healthy background many imported goods crumble, including a number of Paris-tailored paintings. But indigenous creations become hard to single out, works that would be the pride of less favored nations may be born, flower and die unseen in this jungle of art. The work of Guadalupe Posada illustrates this fact. Its bulk only, some two thousand plates, is amazing, while its quality sets a standard of subject matter and style that guides the effort of this, our generation of Mexican artists. It may be that racial fitness gives it an objective value far superior to the range of personal attainments, for his work to this day remains in a noble shelter of anonymity.

Posada came to Mexico in 1888, following the disastrous floods in Guanajuato where he

lost house and family. There he teamed with the publishing house of Don Antonio Vanegas Arroyo, illustrating its penny dreadfuls, pious images, comic poems. Of the work done before coming to the capital we have a number of elaborate lithographs, political cartoons reminiscent of Monnier and Grandville, which are not flavoured at all by the "primitivism" of his later work, highly important documents in the stylistic sequence of his oeuvre. They prove that he was a convert to popular art, and that the quaintness, the grotesqueness, the emphatic black and white of his adult work are the partipris of a responsible artist no more innocent of wisdom than Giotto, come to simplicity through a complex route.

About nineteen hundred, Posada was a fat man, robed in an ample white blouse, very brown of skin, his skull fringed with short white hair. His work-shop was tucked inside the portals of a carriage entrance, on Santa Ines Street close to the Academy of Fine Arts. His tools and plates at hand, he worked under the eyes of passers-by, among them youthful art students, too young to make a difference between this

maker of popular arts and the doings of their polished teachers. Both Orozco and Rivera remember him so engaged, and we may picture the two youngsters digging their elbows into each other's ribs to get a closer view of the master.

He worked on wood, but mainly on zinc, drawing and carving in a single motion of his engraver's tools. He documented himself in two large sketch books which Mrs. Arroyo describes as being full of people in action, "some very nice, some very horrible." He would do as many as six originals a day for a monthly salary of thirty dollars, and "in those times it was a pay fit for a General", swears Don Blas, the son of Don Antonio who was the boss of Posada. The artist lived long enough to witness the uprising of the people in that revolution of which he was the prophet.

Far from proving incompatibility between artistry and daily work, his life seems to have been that of an artisan who humbled his artistic status joyfully, forgot what he had learned from the French lithographers, taking to the coarser medium of block print as the ablest channel to make art serve his people. On the

wall of his little studio was pinned a copy of
Michelangelo's Last Judgement. Conscious of
his own value, Posada must have felt fraternal
towards the Italian, for both obey those impon-
derable deformations that plastic law, through
the artist's emotions, impose upon a model.
Yet he saw no reason in such wisdom to deny
his comradeship with the Mexican worker as a
class. One of his prints "Dance of Death of the
Artisan's" groups the shoemaker, the hatter,
the carpenter, the tailor and (why not) the
painter. Thus identified with his models, he par-
took of their small pleasures and many hard-
ships, instead of peeking at them from an ivory
tower. Posada recreates plastically his own life
and theirs, unafraid of melodrama, stripping
the anecdote from all picturesque addenda,
drawing so directly that his line pulses like a liv-
ing heart exposed. A comparison none too raw if
we take stock of the subject matter to which he
was partial: Horrendous dramas, hair-raising
tragedies, themes of which any decent artist
should beware and which good taste shuns. "The
Wife Who Pours Molten Lead in the Ear of her
Sleeping Husband," "The Man Who Eats his

Own Children," "The Werewolf," "The Child Born with a Hog's Head" are a fair sampling of his somewhat strong taste, despised by the same cultured people who applaud heartily the incest of Oedipus, the hunger of Ugolino, the witches of Macbeth or the Quasimodo of Hugo.

Among other traditional subjects to which Posada gave new life is the theme known as "Skulls" in Mexico, as "The Dance of Death" in Europe. The skeleton intruding on our daily activities, pouncing upon young and old, rich and poor, has always been a favored theme under a feudal social order. In such times the

biological equalness is the only uncensurable allusion to the desired social equality, a tribunal of justice to which the people drags its bosses and, as judge and jury, decrees death. Holbein in Europe was the mouthpiece of the people, his style tinged with ponderous Germanism. Posada, with equal depth, but with Mexican good humor, conjures the skeletons of politicians with tortoise-shell glasses and high hats, of generals whose ribs sag under medals, of ladies hiding their bald skulls under the funereal flowers of imported chapeaus. He reserves his tenderness for ephemeral feminine beauty. "The Dance of the Skeletons—of all the Women Artisans—Hat-makers, Dress-makers—and all Women Workers"; this caption to one of his prints sings like the plebeian voice of Villon of which Posada, who probably never read him, is the greatest illustrator.

Mexican popular taste has always been fond of supernatural happenings. Church walls are piled high with painted ex-votos relating the spiritual consolation of miseries, the healing of wounds, the cure of illnesses. Old print-makers drew the ectasies of the miraculate and the

haloed consolations of the celestial visitor. But
Posada was not the best man to give thanks;
he specializes in other miracles of more disquiet-
ing brand, invents with relish devils and witches,
sicks them onto humans, partitions the sinners
into ingenious hells. Seven dragons born from
under his fashionable jacket greedily snap their
teeth at "The envious Rich Man who committed
Suicide."

Posada is an attentive witness to Mexican
history in the making, the greater for being
fiercely partisan. His choice of events, anti-
dictatorship meetings clubbed and shot by the
police, mass deportations, chain-gang labors of
political prisoners, show him siding strongly
with those dissatisfied workers and farmers that
were to become the revolutionary hordes. The
years that have elapsed since have improvised
fitting captions, bloody corollaries to those truly
prophetic prints.

For decades, Posada was either ignored or
branded a cartoonist. Whatever its emotional
or tragical intent, the human spectacle is
daubed with comical veneer. Recession in time
has taught us the serious intent beneath the

Darwinisms of Goya and Daumier. Orozco entered the portals of fame first in the guise of a comic-strip artist.

Posada's work is such an accumulator of human values that it seems poor homage to separate its plasticity from its meaning, yet his means are worth analysis. He conveys the importance of the personages by swelling their scale, a process heretical to the laws of Italian perspective. In his "Entry of Madero in Mexico City," the President is taller than the ladies and gentlemen who hail him, though these are nearer to us; they in turn are taller than the lackeys and coachmen whose functions are purely mechanical. Time and place shift in a single print as in dreams. In his "Death of a General," the bearded corpse reclines on a pompous bed; from the waist down it becomes the patriotic attributes which symbolize the activities of the Military. The curtains of the alcove breed a file of top-hatted politicians following a hearse in which the General is again seen; plumed horses pull the coach into the thickness of the wall.

His drawings maintain mural density even in

the midst of turmoil. Arms and legs caught in quick action criss-cross into carefully laid diagonals, the bricks thrown by an enraged mob stop dead in their trajectories wherever the laws of composition require. Thus Posada ennobles the somewhat crude dynamism of his anecdotes by making them subservient to geometry.

At a time (1890–1910) in which an attempt was being made to turn Mexico into the ape of European fashions, Posada was one of the very few who recognized the worth of the Indian apport. When official art cuts itself off from local tradition, the latter lives underground, labeled by the higher-ups as folk-art. When the nation returns to its true sources, a work such as that of Posada again becomes significant. Though colorful dances, quaint costumes, vivid textiles and painted pigs will always be the loot of tourists, sterner objects such as are Posada's prints are closer attuned to this land, plastic, tragic and spiritual.

12. MARTINEZ PINTAO

THERE are in Mexico many artists who work in clay, some of great talent, but only one sculptor, Manuel Martinez Pintao. There is quite a difference between working with a soft material, with equal opportunities to add or subtract, a hit or miss technique, and pitting oneself against hard material, wood or stone, without the soothing guide of a maquette, the choice of pasting back the piece chipped off. This difference between sculptor and modeller goes deeper than methods and material, imbues the finished works with incompatible spiritual atmospheres.

Those who model, having polished to a finish the clay statue, transpose it into hard material; this stage of the work is that of a copyist, who duplicates the clay original with co-ordinate measurements. The artist, or a stone cutter, can tackle equally well this translation from one medium to another. It is folly that a marble should acquire the surface of pawed and kneaded clay. If the model is docile to the qualities of

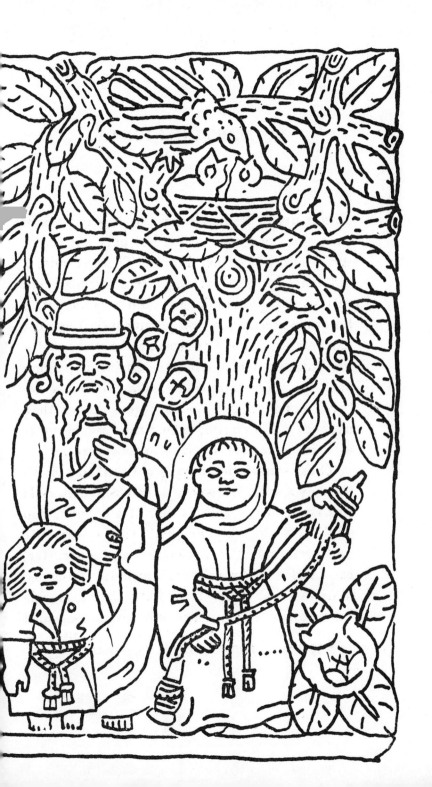

☛Pintao: "Holy Family." Bas-relief.

soft material, the resulting marble will be a lie. Or the artist tries to suggest the marble with clay, the statue being in the end only the lying image of a lie.

The true sculptor chooses his material with awe; for his work will logically be born of his choice. The style of the finished piece will be dictated as much by the material as by the sculptor, handling his tools in accord with density and texture, subjected as he is to its organic laws. The clay modeller is free of technical shackles, indulges at will in artistic flights; the true sculptor, approaching his work as carpenter or stone cutter, will be more humble in his conception, wisely limited in his execution. He cannot conceive his subject as detached from solid matter, would judge it indecent to make a stone masquerade, let us say as a cloud.

It is obvious that a statue, be it a Venus, is organically the same as the uncut marble. Michelangelo's test of beauty for a statue was that it would roll intact from the top of a mountain to the valley below. A beautiful statue should be in the nature of a beautiful rock.

To submit himself to such tyrannical laws

implies on the part of the sculptor a true as-
ceticism, a humble approach to his daily task,
an inspiration circumscribed by execution. He
cannot weaken his block by representing a hand
with outstretched fingers, unruly curls or float-
ing garments. If he comes to confront a knot
in the wood, a soft strain in the stone, his plan
must change. He is slave to the law of gravity,
as sovereign in sculpture as in architecture. The
basic area, the elevation of the center of grav-
ity, and a safety margin in their pyramidal
relationship, will affect the shape more than
any search for beauty.

If the sculpture is a bas-relief, to those rules
will be added the laws of composition shared
with painting: a symmetry in the partition of
areas, a palette of smooth and rough, of con-
cave and convex, to differentiate areas as would
color in painting.

Pintao is among us the paragon of true
sculptors, unknown by most, so busy with his
work as to be somewhat antagonistic to news-
paper folks. He is in direct line of spiritual
descent from those Colonial artisans, conscien-
tious, slow and headstrong. He is not a primi-

tive, a label that is disdainfully proposed for those who do not follow theories of mass production and poster-like aesthetics. He is a man perfectly conscious of the blessed limitations of the craft, whose mallet and chisel have defined his style. If the proportions of his sculptured bodies, their attitudes and garments, seem close to those of Colonial times, it is because ancient sculptors were as much conscious masters of their craft as he, and gave similar solutions to the same problems.

His bas-reliefs are of a religious tenor. Born of rigorously geometric precisions, the tiny figures soon come to buoyant life. The cowboy-angels who lasso the Dragon of the "Assumption" truss him with knots made to tighten with each wiggle. An Archangel rolls up his sleeves, to better saw in two the Beast. Mary in the "Holy Family" unbuttons the collar of Jesus, so he may romp and play as befits his age. Without recurring to the picturesque or exquisite, with such humble vocabulary as leaves, a stump with nestling birds, a spindle, monastic robes, Pintao recreates in terms of God the everyday spectacle.

13. JOSE CLEMENTE OROZCO

". . . and the King strolled proudly over the streets of his capital, dressed in magnificent garments, the weaving and embroidering of which had cost several fortunes. No one could see any clothes at all, yet no one dared a question. And the King said nothing for his regal eyes could not perceive less than those of his vassals. Courtiers bowed and crowds cheered. A child shouted: 'He hasn't any clothes on!'"

We, post-cubists, are likewise strolling, proud of our metaphysical garments, golden section, fourth dimension, tactile qualities, etc. The critics laud our regalia, the public stands in awe . . . each stroke of Orozco's brush echoes the child's voice.

His sources are genuinely American. The United States contributed the mechanical element to his work, Mexico the dramatic. The Italianate rash from which he suffered a while, his dipping into cubism, show his irritation at being different from the herd. A failure as a plagi-

arist, he now resignedly explores his own untrod jungle, blasts his own road.

Every valid artist lives ahead of his era, connives with and enriches those not yet born. Pitted against contemporary taste, he remains alive when his epoch dies. The artist of today, terrified of the spirit, remains bogged in the letter. Cubism dictates his output, clamps onto art an inflexible carcan. Lone rebel, Orozco maintains the supremacy of the spirit, unafraid of describing facts and raising issues.

Compared with orthodox moderns Orozco appears romantic. This dubious dubbing comes from the lips of those who idolize geometry in paint, devotees of the golden section and priests of dynamic symmetry. They are right for this instant of time, but in a few years, when cubism and neo-cubism will have receded into the past, this romantic label will wash off, a more essential quality will appear, Orozco's work will be called monumental.

This tectonicity grew in ratio to the limitation of means that the painter imposed upon his work, a technical famine that would have crippled a less heroic personality. In his latest

and greatest frescoes, the multiplicity of colors gives place to a palette of vine black, ochres and bluing blue. Having shed much academic pride, his drawing is now audaciously simple. His murals are at ease within an architecture, not because he paints people gigantic in scale, but because of a symphonic quality that stresses mathematical intervals, a denominator common to music, architecture and painting.

Such discipline answers an ascetic urge. Blessed with uncommon craftsmanship and thorough anatomical knowledge, the painter casts aside all that was his already, and to better commune with his daemon, lets go of accidentals. Looping the loop, his most recent works seem so easily begotten that many a pedant, granting that they are good sketches, insists that he could not carry them through. This digestion of man by his own blazing vision is indeed a perennial drama. This drastic purification denies everyday necessities, laughs away the advice of friends and critics alike. The struggle left aesthetic scars in his early frescoes, but the peace won is also strength, not the languid state of the weak, in which no conflict exists,

nor passion. A climax of emotion permeates
this art, suiting the esthete who sees there ab-
stractions, enthusing the moron with its melo-
drama. The painter, vomiting both, fears mostly
the nudge of the intellectual.

In his work, the processes of ideation, com-
position and technique succeed each other
quickly and are so interwoven as to be practi-
cally simultaneous; the artist himself cannot
dissociate them. He said once, "painting comes
as natural as eating." But Nature is not simple,
and the phenomena of nutrition, digestion and
assimilation, in its complexity which the man
who eats blessedly ignores, is an excellent paral-
lel to this phenomena of painting, physiologi-
cally latent in Orozco.

The core of his work is this inspiration which
neither recipes nor example can transmit, whose
rules can be mastered only by spiritual experi-
ence. When at work, the painter must remain in
a mediumic state of passive expectancy, for all
efforts to press a conscious logic on the wall in
gestation, would result in injuring those impon-
derables more vital to his art than articulate
laws.

Orozco expresses his concepts anthropomor-
phically: man reigns in his work, his tools, his
architectures; landscape appears only in short-
hand version, to strengthen by contrast the
theme. This obsession with man is not eulogistic,
for the artist relishes the debility, the incon-
sistency of his subject. He describes the human
search for logical and beautiful aims, but the
gesture lacks reach before, and fruit after its
apparent consummation. His men are not ac-
tors in the mimicry of despair, they just hud-
dle together, bathed in a super-human, even anti-
human influence which fills their lungs, oozes
from their vitals. If Orozco was a true pessi-
mist, his art could not match the positive affir-
mation of an architecture. Man frustrated af-
firms a potentiality of grandeur. Thanks to the
three positive virtues, Introspection, Force and
Grace (fresco in the House of Tiles) man har-
monizes in the end with the invisible.

His plastic solutions are simple and lucid.
To fill an arch he arches a human spine (St.
Francis). He frames a door between two diago-
nals whose optical junction functions as pedi-
ment (entrance to stairs, Preparatoria). An un-

buttressed diagonal crosses a whole area (The Trench). Orozco, inch-rule in hand, does his best to compose in two dimensions, to carve a plane into appetizing portions, as his post-cubist colleagues do. But he is born to greater things, to compose in depth, ordering orbits for the revolution of volumes in created space. Projected upon the vertical of the wall, such depth composition will leave a two-dimensional residue only as its corollary.

Though saturated with dangerously dramatic elements, Orozco's painting remains plastically sound, for he is an artisan well able to handle his tools. He himself has a hand in the slacking of his lime, the sifting of the sand. Rather than for psychological reasons, his colors are chosen for their permanency in fresco. He gave proof of his respect for the physiology of murals when he asked his master mason and his gang to repaint frescoes partially destroyed by a mob. Having built up the wall and ground the color, their physical intimacy with the job seemed to him an ample corrective to their lack of aesthetic training.

The ideas expressed in those murals sum up

into an impressive creed. When cornered, Orozco denies being responsible for those thoughts, admits they are his only as they tie technically with the wall.

He does not bow to the Past in the solution of his daily task. If his compositions clash with historical precedents and euclidean postulates, the artist begs forgiveness, but does so with a smile.

Merida: drawing.☞

14. CARLOS MERIDA
1928

I

DRIVEN by the iron hand of a discreet and implacable taste, Carlos Merida has discarded, as the balloonist drops ballast, not only elements pictorially doubtful, but those legitimate tricks and recipes with which even good painters stuff and prop their work. The aesthetic creed of Merida is defined better by the ponderous list of means that the painter purposely renounced. He avoids linear perspective, that paradoxical convergency of parallels, of which Raphael wrote with scorn as "those measurements that seem to be, but are not." He repudiates also the suggestion through values of a film of atmosphere whose elasticity defines the volumes. His pictures do not use a light with localized source. They are imbued with a diffused glow which affirms local colors as flat areas. This painter of tropics has thus to do without the facile duplication of sunlight, the easy way of describing

objects by exalting the contrast of values. To a mind so strong with scruples, modelling appears perhaps as a means more akin to sculpture than to painting. He avoids also tactile qualities, the rough and juicy strokes suggestive of mastery: he applies his pigments without visible brush marks, with a mechanical monotony which however respects and reveals better than other ways the physical plane which is the picture. The line that Merida prefers owes little to the twist of the wrist or the spur of inspiration; ruler and compass define for him the circle, the oval, straight verticals and horizontals. He shies from dynamic composition, using a vertical median axis with symmetrical wings, or simple variations on this theme.

This pictorial world in which Carlos Merida rejoices should then be without space, without volume, without light, without linear swing; something of a world in two dimensions, where bulk and movement would exist no more than in a carpet or, to soften the blow, in a stained glass window.

But this good strategist guardedly escapes defeat; in his tactical retreat into a world of

purity, he preserves intact a factor which gives him victory. The role that the artist refuses to drawing and modelling falls to the single means of color: color alone recreates space, volume, weight; in the end his painting is enriched by this extraordinary refinement of means.

Merida is a conscious master of this geometry of color which reaches deeper than the geometry of line. Because of this, the scaffolding that his drawing raises is not intended to solve problems, is no more than the geographic boundaries of his color. From tone to tone, an optical magic multiplies vibrations, living intercourse binds the parts into one picture, gives it more life than any handiwork could. This optical life of the picture is after all its reason to be, and to it the physical picture must bow.

The artist has lately applied this knowledge to drawing; in his earlier work the line is of such orthodox geometry as to clash with nuances. In his last water colors the geometry becomes on purpose deficient, as if reflected by an unruly mirror; such lines of more human lineage pass through the eye without wounding it, to reform in the brain, though not on paper, a

puritan architecture. Both line and color, by weakening their physical impact, mature into spiritual reality.

The artist even indulges now in what must seem to him immoral cavorting, certain modulations within a flat tone, a sly modelling of volume under the guise of technical accident, dicreet tactile qualities, a few visible brush strokes.

By digging a little wider than before in the treasure chest of pictorial resources, Merida varies his art without deviating its course. This oeuvre, all intimacy and restrictions, is yet not a drawing room display or the relaxation of a dilettante. His works speak "sotto voce" but with deep conviction of his Indian birth and breed. To bellowing politicians whose platform is to civilize the native, the artist offers an alternative of equally instant necessity, a redemption of the white man by the Indian, who can well teach him physical and moral nobility, and over all contemplative peace.

II

1936

Be it for shame or glory, Carlos Merida is the pioneer of the so-called "renaissance" to which his show of 1920 in Mexico City gave both birth and a healthy jog. He was also the first of this group to cleanse his work of the picturesqueness of folk-lore, even though he well knew how to translate it into sound plastic terms.

Following a rigid process of introspection, Merida came to question even this impressionist painter's paradise that is the world as seen through the human eye. At last he has come to rest his art upon this rock bottom level labeled "abstract," where color and line do not masquerade any more as outer things, where the painter's aim is not any more to tell a lie.

He brings to this recondite work the same racial grace used in depicting his own tropical land. The silent geometries, the reticent sensuousness of textures, the earthy dampness of color, speak still of a land and a race, but sublimated unto a plane where neither tourists nor

railway agencies have access.

We, who were not brave enough or rash enough to do the same, still clinging to picturesque themes and realistic vision, gaze with longing upon Merida as he opens his path through those rarefied regions where appearance gives way to substance.

15. THE CRITIC, THE ARTIST AND PROBLEMS OF REPRESENTATION

An artist who turns critic is handicapped by a great pride and a great humility. The medium of words, the process of intelligible analysis, are foreign to his trade and in the use of such tools his unfamiliarity makes him humble. His pride is a reflection of the fact that he has over the professional critic the advantage to which Mark Twain pointed—that same advantage that the bug has over the entomologist— he knows his subject from the inside.

Artist and critic are of opposite types and what befits one is poison to the other. The facile approach to all the sources enjoyed by the modern critic, his mind filled with illustrations of all styles of all times, is, as regards the painter, a dubious blessing. The artist of yesterday, limited as he was by the lack of automobiles and of photography, had as a result an innocent faith in the one local style of his birthplace or bishopric, and a lifetime to dig far

118

down into its possibilities, to a depth made possible only by such a narrowed approach. His colleague of today, unless he be of the strongest, will ease himself by leaning on an academic knowledge of the art styles of the past. All he knows, from Altamira to Miro, will be ingeniously put to work in pictures whose only defect will be a lack of creativeness.

True creation must start from nothing. For the artist who only approximates this godlike attribute, true creation must at least start from little. The real painter approaches his work as nakedly now as he did in the prehistoric cave. This emptying of himself, this vacuum cleaning which is the first step of creation, is the absolute opposite of the data gathering and file ordering of the critical type.

The hypnosis in which the creative artist must dwell will develop his emotional, intuitive functions, but will make him less fit to express himself through the more commonplace, more analytical channel of words. There is a general and valid acknowledgment that the better the painter the dumber he must be, and out of this dumbness the critic is born and makes hay. In

our day the critic has become the indispensable
middleman, sandwiched between the work of art
and its public. His oratory in behalf of his
dumb friend, the artist, more than often irri-
tates the latter. Yet critics have their raison
d'être in the reluctance of the artist to act as
his own mouthpiece.

It is little wonder that the artist whose whole
job is to put separate things together, to weld
them solidly through composition and common
emotional climate, will not see the point of at-
tempting the reverse movement. To take a well-
fused painting and tear it apart, design here,
color there, spatial, tactile, etc. qualities, each
cut clean and labelled, all ready to be dumped
in an alcohol jar, is the job of the critics of
our day, as typified by a Barnes—a kind of
post-mortem trade. Much fun has been made of
the emotional criticism of yore as opposed to
such a so-called scientific attitude. Yet the case
for the old-fashioned literary critic is still valid.
He sensed the picture as alive and an autopsy
would have seemed to him akin to murder. Pater
attempted to parallel in words the mood of
the picture, justly deemed all-important. Line,

color, composition, were minimized as so much studio slang.

That the public loves to go behind the scenes does not impair the fact that its logical place is in the orchestra. So much shop talk has been aired in books discussing modern art that it has been forgotten that the picture is after all a spectacle to which for its full enjoyment one must bring a kind of ignorance or innocence. There is one problem, however, which is of interest to both artist and layman and stands as the meeting ground of their relationship—the problem of representation.

That pigments laid on canvas have anything to do with a representation of the world is not in fact apparent. Yet man, whose eye is trained at detecting the elements of natural spectacles, is quick to interpret into symbols otherwise meaningless patterns. Thus, as Leonardo points out, we see faces and monsters in the cracks of an old wall or a moving mass of clouds. Contrary to the layman's opinion it is not the representation of nature that is difficult in art but, if such be the aim, a severance of the connection between painting and representation. The least

clue of line or color, however faint, will set the associative power to work. An ink blot on paper will create a rough but effective illusion. The black may suggest a hole in the paper affording a receding vista or become some object lying on the sheet of paper. Whatever the reading, an illusive space and volume are created. Such humanized interpretation of plastic facts multiplies with any stroke, scribbled line, change of value or of color in a picture. The human eye is trained to interpretation and the human mind follows its routine of attaching some objective reading to any system of line or color, be it in nature or in art.

It would be a cleaner job if one could paint with line and color only, barring their associative corollaries. In fact, abstract painting, using line and color per se, would be the only realistic approach to paint, denuded of what in painting smacks of magician's art and childish make-believe. But it appears evident from even this simplest example of the ink blot that, however desirable it would be to isolate line and color in some kind of sterilized vacuum, to study art 'in the abstract' as we moderns put it

quaintly, by some inescapable process of our imagination the outside world does get all mixed up with our diagrams. Picasso, try as he may, cannot shake off his guitar and his pipe. So, if we are to paint, we are to accept representation, the introduction willy-nilly of a subject matter woven into painting, as essential to pigment as is its physical density or chemical properties. Though such a conclusion lacks sophistication there is little harm done at that.

The incompatibility between story-telling and plastic equilibrium is an entirely fictitious creation, a scarecrow propped up by dealers and critics to shush a dissatisfied public. Throughout the history of art, representation and plastic qualities have grown and prospered as dependent on each other as are Siamese twins. But for the last sixty years a strange disease has overcome painting, the twins have come to hate each other and each would cut himself loose from the other even though such a step means death. Compared with what went before them, impressionism and cubism, those supposed opposites, seem very close to each other, intimate allies in their war against subject matter.

version of the world. Freakish distortions, multiple exposures of moving objects, hazy focusing of planes raise questions that painters true to nature would have to face. Furthermore, human vision with its double foyer and prehensile focusing multiplies the problem of camera vision *ad infinitum.* And if we consider the gloze that the human brain inscribes over the margin of human vision it becomes apparent that academic art is no truer to nature than any of our modern "isms." It would have been easier fifty years ago to state that academic painters represent the world as it is. At that time 'science' had a kind of cumulative and permanent meaning; since each optical fact is related to a physical, the painting of a collection of facts seemed to have a certain value as scientific data. To infringe on this pure representation, to distort imaginatively, would have been a sin against science. Since those days, though, science, having stalked matter into the atom, has shattered this atom into something more like energy than matter. The world, as modern science conceives it, is again full of mystery. Its laws are relative, submitted to a kind of free will on the part

of matter. These unforeseen qualities, this dynamism, must be built into any picture that is to reproduce the scientific reality. And this structure we do find in the work of the greater subjective masters much more than in the clear-cut, clearly labelled, so-called academic painters. This justification into a larger meaning of what up to now passed as artistic temperament means that both objective and subjective do beat with the same pulse. Our own human mechanism is also an integral part of the world, and as the Chinese clearly expound, painting the laws of mountains and trees and riverfalls is but an introspective excursion. Painting, even if we start our quest with the commonplace assertion that one must paint "real," becomes on examination a very spiritual affair.

No matter what objects appear in the picture, the painter conjures them up through his use of space and volume. Their representation on a flat surface outsmarts a magician's trick. That canvas and color should become human beings, trees, mountains or sheep seems more freakish than the pulling of rabbits out of hats. And it is true that a certain kind of natural-

istic painting is no more than a magician's sleight of hand. Not the representation but the suggestion of space and volume is the painter's trade and therein lies the difference between imitative and creative art. If space and volume were to be absolutely convincing, art would be imitative. The painter dealing with lines and colors is bound to create a kind of third dimension, as lines and colors will do even when left to themselves. But to remain a painter one must use such magic properties with a grain of salt, wink at the onlooker to make clear the fact that the painting is only an illusion, preserve within the painting certain areas where color and canvas refuse to play the game. Hence those purposeful limitations that some deem defects in the masters: the strong unnatural outlines of Botticelli and Ingres, the undisguised brushwork of Rembrandt or Cézanne.

A sculptor achieves volume by gauging its internal space; the painter achieves volume by closing up space around it. In the true painter's language, concave and convex can stand for space and volume, as it is akin to the semi-space or semi-volume that the inside or the out-

side of a spoon illustrates. The painter who favors volume will contract the object and make it compact, avoid gaps between arms and torso, treat fingers as a single mass. Such shapes as those of Renoir would be translatable into good sculpture, were it not that the painter reasserts himself at the meeting point of shape and space, where the slight trembling of a line, a lack of focus will reassert the painted atmosphere that the rounding of the shape nearly denied.

Painters who select space as their major theme will prefer unsculpturesque elements whose thin members are like arrows pointing to width, height and depth. Hence the fondness of Chinese painters, space-hungry, for lean stems, bare branches—hence also the perspective lines and surveyors' stakes that are the lances of Ucello, the so-called "decorative" stripes of Matisse.

Because of such hidden reasons art has built up its peculiar bric-à-brac of subject matter, a medley of fat or lean objects to which each painter and each school for an essentially abstract purpose comes back. And it is a happy coincidence that in the days when the Church

was patron of the arts, the painters, translating the sacred symbols into terms of their craft, could we. arm up to the combination of horizontal and vertical which is the Cross, those primary volumes with which biblical robes, stooping postures endow the human body, that pointing to cardinal directions of ladders, sticks and lances.

The hunting ground of the painter is strictly this physical world. The constructions of the mind which a philosopher, a scientist, may expose nakedly, can be referred to in painting only by representing objects possessing on the physical plane a similar order or set of properties. Many objects have a metaphysical meaning disconnected from their plastic appearance. For example though man, this microcosm, is the creator of balanced logic, his body, the only part of him with which painters may deal, with its shifting lines and suave modelings is no more able than other animal bodies to express such constructions of the mind. Yet those man-made constructions that come within the range of painting are eminent illustrations of mental processes. Hence the fondness of great periods

for using the human body as only one of the ingredients of art, fortifying it with painted architectures that convey a static order. What those tiny houses and those cubistic mountains of a Giotto bring to his pictures is this brand of human logic, that the human body fails to convey.

For the last half century sophisticates have jeered at paintings that tell stories. But as action follows reaction, subject-matter was to make a vengeful comeback. There is of course nowadays a group of painters who, stung by social consciousness, present subjects chosen to advise, infuriate, or arouse enthusiasm in the "masses." Their achievement is weakened by the fact that such well-meaning painters did not fully realize that a new approach to the grammar of paint was the one condition essential to making the story legible. More profoundly typical of the new plebeian attitude, though forced into it very much in spite of themselves, is the position of the surrealists. It is true that the stories they tell are not at all nice, are barren of all social sense and have been industriously shorn of logic. But their

pictures are definitely story-telling, with the special grammar, patient craftsmanship, photographic slavery to detail with which Gérôme glorified his odalisques and G. J. Brown his bootblacks. A look at such pictures makes it obvious that the painter is no longer painting for pleasure but that painting is truly a business which presupposes the existence of a public and caters to its reactions. Paradoxically, though there is little mental finesse behind a Monet picture, its disregard of convention, its sheer brawny relish in brush stroke and cheesy pigment, make it the aristocratic gesture of the man who does as he pleases. Though there is much sophistication behind a Dali picture its academic treatment spells the vulgarian, the man who works to please others. This is an important turning point, a very much needed attitude after the orgy of selfishness characteristic of the elder moderns. Much against their own claim, it must be said that Dali et al. bring painting back to a point where it is no longer a masturbation but a trade. In his new role of tradesman the painter must evolve a technique adjusted to the correct or moving recitation of

a fable. Description becomes to him what diction is to the actor, and less trust is placed in the sheer qualities of paint.

A general comeback to story-telling is unavoidable. The craft of painting is in its healthiest state when painting is used to an end, just as a healthy body is put to work. Painting for painting's sake is like the man who is afraid of failing health and totters through desperate medication and endless build-up exercises. Both for art and for man an anatomical interest in one's own carcass is born of a pathological fear of death. Modern art has become thus a language of interrogation and exclamation signs, fit to express emotional climaxes or introspective states but lacking the articulations needed for objective description. To be vital the comeback to subject-matter must be linked with the creation of a fit plastic language. Unhappily the surrealists sidestepped this problem, choosing as more expedient the wholesale plundering of 19th century academies. This weakens their effort, and as is true in the case of the Preraphaelites and other 'neo' movements, a still-born aroma pervades their achievement.

Braver pioneers of the new trend were perhaps the Mexicans who in the early twenties frescoed the walls of their public buildings with histories. Their painters, living as craftsmen in close union with the master masons and workmen with whom they collaborated, did work of social import, forgot the ivory tower, and were recognized as useful by their fellow men. And more important, their plastic language, though fit for descriptive purpose, was not a surrender to the past.

This is the new trend. But though it represents a most intelligent desire on the part of a painter to take his place openly in the social structure it is not without its drawbacks. Set on a pedestal the artist was at least removed from the crowd, did not interfere with its traffic. Shorn of his prestige he makes a poor showing among his would-be fellows; and workers, both the brawny and the white collared, eye him with suspicion. The truth is that painters are in the bastard position of being neither bona fide workmen, as are carpenters, plumbers, etc., nor in tune with intellectuals. Their craft is certainly

manual and their dominion over their material and their zest in handling it are typically characteristic of a craftsman. But whereas one easily understands the use of a table, or of a chair, or of plumbing, and thus partakes in a social intercourse of exchange with their maker, one is more in doubt concerning the good of a picture. It is one of those baffling objects that like a piano are rather a nuisance unless you know how to use them.

In truth a picture is an object only in appearance. That is, a picture in the dark, though physically unchanged, is no longer a picture. Only its optical projection into the human eye gives a picture its sense and its worth. The physical object is just a projecting machine; and the optical image, the real picture, exists and functions only in the semi-physical, semi-spiritual world of the human brain. With its body as physical as is a chair or a table, its function confined to the sensorial fringe of our mental reaction, and its aims those of spiritual introspection, painting bridges our whole universe. The painter who deals in such a dubious and impractical affair will never, try as he may,

be accepted as a worker among other fellow
workers.

The attempt on the part of the artist to ad-
just his relationship to the living is only part
of the problem. If all that he asks is food and
shelter, the probability is that he can sneak
through this life without awaking much antag-
onism, meanwhile making ready his post-mortem
shows. More important to him, however, than
this compromise with the living, the artist has
to compete in his trade with the dead. They
are his tutors, too, for more painters were
made conscious of their gift while making
the rounds of museums than while standing in
front of beautiful sunsets. But as soon as the
artist starts to paint, the dead become his rivals,
and from the level attained through the slow
sifting of the centuries, from the vantage point
of their Olympian position, they become for-
midably alive.

There is of course a hypnosis in museums, an
awe born of the gold curlicues on frames, the
dust-encrusted varnish, the labels with their om-
inous dates. The old masters in lace and long
beards, for the layman seem to be there and

beckon. Even more impressive, if plainer, is the approach of the painter who, though he strips the work of all this ballyhoo and the men who did it of their unwanted halos, is still confronted with an excellence so great that matching its qualities means the work of a life-time and surpassing them seems forbidden. The "bigger, better, faster" slogan of the mechanical engineer is here useless. Progress in paint, the amazing new colorings born of organic chemistry, the scientific theories of color separation, are of little help. The more the painter knows, the simpler his technical needs. All human expression may still come out of the few earth colors, yellow ochre, red ochre, terre verte, the black and the white that composed Apelles' palette.

This chumming with the dead, which is both a spur and a restraint, is mysteriously spoken of as Tradition. It is a popular belief that the modern artist remains aloof from such, that he willingly would burn the museums the better to build from new premises. Yet paradoxically the fact that his work has an appearance distinct from that of the masters gives it the earmark

of the true follower. For the masters are such because they did not copy. Their work eternizes a peculiar climate born of themselves and their own passing world. To follow them one must also face one's self and one's world. To assume their surface quality is to misunderstand its deeper spring. Thus tradition is not, as some would have it, a pedantic historical knowledge but straightforward human relationship.

Tradition is also this continuity of the craft that leads the worker wisely to submit to the laws of his material. Instead of curving his own will to their logic the beginner fights against natural laws. He will polish a wood sculpture and make it look like china, but an adzed plank has more organic beauty. An egotist may paint a mural that surpasses architecture, but the very doors and windows of the building shame it out of plastic existence. When one knows more, one learns to collaborate with wood and pigment. A closer and more widespread bond than even that of historical tradition will thus bring into close relationship, through their use of similar materials, craftsmen who have never

heard of each other. The Mayan sculptor in Yucatan, the medieval carver of European cathedrals never met. Yet they both learned to cut their stone the same way, to respect the trace of the chisel as an enrichment to texture, to strengthen their angles towards an ideal ninety degrees, to suggest round surfaces by 'cubing' them into polyhedric facettes.

If the good craftsman must be at peace with his material, he must also collaborate with his tools, including his hand and eye. Too often does the artist put them to freakish uses. Yet the way of least resistance seems to be the way to beauty. Leonardo's stroke is the left to right and downward one natural to the left-handed man. A Pompeiian fresco, a Monet, both bespeak the easy twist of the metacarpian bones that rule the brush. The perfect lines of an Altamira bison, of Michelangelo's Adam or of Rouault's Christ all obey the commonplace laws that arm and hand muscles dictate.

The laws of the body, of the material used and of history cooperate to bring all art to some common denominator. They account for much of what we know as style—that is, to the

layman, the quotient of artificiality in the grasp the artist has of Nature.

Style is in a way an unwanted interference with the artist's end, for what he aims at is to give us Nature. He is unconscious of style, for style is a thing of his bones, of his craft and of his birth. But the artist, seeing Nature as a spectacle outside himself, wishes consciously to capture and assimilate her as a desirable thing that his job will make available to others. Just like the scientist, he wishes to make a census of the world in a most objective way. But his gathering of facts through optics instead of logic results in an unorthodox version, a shuffling of facts as methodical but as unexpected in its implications as the neighboring of words in a dictionary. It may be the effort needed for this new reading, the jolt to established habit, which so irks the layman that he prefers to deny the validity of such research.

Yet, while Nature contains many elements that are easily translated into words, many pragmatic things whose "why" even a dry mind may fathom, it contains also a luxury of creation, an interplay of shapes and colors that up

to now no scientist has touched. A butterfly wing seems as gratuitous in the natural realm as a painting in the man-made world, and mimetism seems a poor explanation for both. Representational painting is a subtler and richer instrument than abstract art in that it gathers to our human use facts that like the bloom of a cheek, the white of a swan, the glow of the underbrush, are not as yet defined or labelled by a selfish need.

Critics, being by trade bookish, have created a fictitious artist in their own image. They jam him full of historical pedigrees, for dates are to be found in books and can be argued or authenticated. They make him also a battleground of styles, for with most of them comparison has taken the place of appreciation. They thus emphasize facts concerning historical tradition, but the laws of material and body, and this all-important holding of the mirror to Nature, are minimized or forgotten.

The artist is scarcely the introvert busy within a cult of technical "chinoiseries" that the critic makes him out to be. The few direct sayings from artists on art are so astonish-

ingly simple they hardly bear quotation. Typical of the painter's point of view are Ingres' "Copy the model with great application" and Matisse's "One must feel that one is copying Nature."

Considering himself as a copyist the painter spares no pains or expense to catch Nature from some vantage point. Cézanne would wait patiently for days before he could ambush the sunny day, lightly clouded, which his critics translate into an esoteric geometry of color. He ordered special windows for his studio, whose carefully increased light endows still table and bottles with a Cézannian style. Rembrandt became the mechanic of his own studio, juggling light and shade through a system of panes and shutters of his own device, in whose aid he had more confidence than in the mysteries of the soul's alchemy. It is little guesswork to see Correggio musing lovingly through the Correggiesque hours of twilight. Nature, more than man, has mothered all styles. Impervious to color theories, much color photography of our own day will insistently happen in the manner of Caravaggio.

The old-fashioned literary critic, rather a poet himself, saw more keenly than the scientific critic of today Nature's imperial quota in art. Observing through the picture the natural spectacle that had given it birth he praised the painter for his women's beauty and the serenity of his sunsets. Raphael's work may be divided and studied successively for its unbroken line, its subdued use of space, its geometrically oriented volumes, its insistent local color. Those aspects may be bared under the scalpel of the critic, like the liver and lungs of beautiful women under that of the surgeon. Yet the good public are within their own right to enjoy their women undissected and state truly that Raphael is the painter of virginal beauty.

It is true that the painter, a Nature lover wishing to give you Nature undiluted, between the contemplation of a model and the exhibition of the finished picture has to go through many bizarre manipulations, many plastic speculations that will seem artificial to the lay mind. But the critic, instead of exposing these intermediate stages, should give the public a chance at the blessings of ignorance. One can enjoy

the beauty of a child without rehashing the sometimes unsavory secrets of the nursery. One can see a play without crowding in the wings to rub elbows with the stage-hands. This fashion of knowing all and telling all about this craft of art-making will probably become obsolete together with the fad of art for art's sake. If representational painting is to stage its comeback soon, critics and public would do well to go back to their seats and face the stage, so that the "representation" may begin.

16. ART, QUICK OR SLOW

"Le temps ne fait rien à l'affaire."—Molière.

IF IT be true that the last thing a fish is aware of is water, in the same way, because it pervades us from out and in, are we ignorant of the more permanent characteristics of contemporary art. Whereas we see only diversity, even points of dissension between the works of modern masters, there will remain, a few decades from now, the perspective of a school as homogeneous in its output as the work of the eighteenth-century painters, if less amiable. It is even probable that art from the beginning of impressionism up to the death of the School of Paris will seem a logical curve, an unbroken development toward shorthand methods and the selfish use of a private code language, as opposed to the catholicity of the aims of art in most other periods.

Monet was a powerfully built fellow, and painting would probably not have been his pet

trade had he not developed a brush stroke broad
enough to insure sufficient exercise for arm and
wrist. Landscapes became a natural subject-
matter for the people who enjoyed outings, and
who were strong and healthy enough to carry
their easels on their backs. The artist painted
for his health; the public was no more taken
into his confidence, and painting switched from
a universal language to the status of a free-
masonry. That the next generation, being of a
less sturdy health and of a more decadent turn
of mind, enjoyed the somersaults of the spirit
more than those of the body, did much to ex-
aggerate this state of affairs. Casting aside its
religious, moral, and social bonds, art flung it-
self into a dance of the seven "isms," of which
the last stages are rather shameful, considered
as a public performance.

One of the best definitions of modern art was
given by Picasso, by negation—as Saint Thomas
was wont to describe God—when he said that
we were in need of a David. The crystal-like
purity of David's descriptions, the logical sub-
divisions of his plan, are the oratorical tools of
a man who addresses the public, of a worker

who knows that the responsibility of the artist who creates a picture, in which the minds of generations will dwell, is at least equal to that of the architect in planning and building a house. Such a picture is usually built up through slow craftsmanship, permanency being an essential of the architectural mind.

Patience in art, the time involved in the physical creation of a painting, is still for the layman a measure of its excellency. And quick work, the freehand and shorthand technique of the moderns, is the basis for most of the outspoken criticism of modern art. Yet, when the architectural urge is missing, sound craftsmanship cannot save, cannot even make a picture. And freehand technique is a befitting medium in which to voice the language of passion. That it has been misused of late for modish and trivial ends must not make one forget that it is the natural language of a Van Gogh or an Orozco.

We know by the letters of Van Gogh that the great master of his type works with his mind at a pitch that it would be exhausting to sustain. Such exaltation is made genuine and fruitful only through long years of emotional experi-

ence and technical study. To such a master, the moment of work is what to the saint is the moment of ecstasy, nourished and developed by the slower process of meditation and mortification. To attempt a slowing up of his painting technique would result for the artist in a distinct loss, a muddling and an obscuring of the unmarred mental image that he envisions as a start.

While quick art has always been linked, and rightly, less to illustrative than to emotive themes, the more careful techniques are commonly believed to be the natural language of academic art, meaning the uninspired objective renderings that the layman still considers as common sense. It is true that patience in art has been associated with secondary figures like Bouguereau and Gérôme; hence the usual linking of so-called objective art and sound craftsmanship. But it is of course obvious that great masters transcend such flimsy boundaries and that Dürer, Ingres or Pontormo used the coolest and most painstaking technique as a medium for the most inspired vision.

The fact that painters like Gérôme do repre-

sent the world as it is could have been sustained more easily fifty years ago than now. Scientific research has since exploded the atom into something more like movement than matter. It is proved now that an art that represents the world as nineteenth-century common sense wished it—labeled, clearcut, and sturdy—is really an artificial, misleading translation, while truly creative art, with its suggestion of complex inter-relations of dynamism and of elusiveness, does capture a deeper and a truer version of the world, even in its scientific and physical sense.

Photography, through its dehumanized eye, upholds for us this point. Even among the everyday millions of amateur snapshots, how few correspond to the ethic of the bourgeois eye! And when a great artist works with this, the most objective of mediums, his work does not recall the so-called objective work of mediocre artists, but can only match the work of the more subjective masters. Rare are the masters of photography as are those of painting; yet an Atget, a Weston, weld objective and subjective into one in their indubitable masterpieces.

All great artists have transcended the limitations of any one technique. Dürer, painstaking and dry-cut as much of his work is, did wash his extraordinary water color, depicting the dream that he had of the end of the world, in an atmospherical rendering of rain and fog that anticipates Turner. Renoir, in some early landscapes, painted the trees leaf by leaf, an exercise in discipline which may have won for him an ultimate freedom. To each mood of man corresponds a given scale; and a broad mind, to express itself thoroughly, has to make use of the whole gamut. The complete work of art, as does the animal body, brings to a living unity materials as dissimilar on a spiritual plane as are the bones and the nerves, the veins and the muscles. That the language of art for the last sixty years has been mainly a series of disconnected exclamations is not wholly an indictment: it did befit it to express climaxes of emotions and those twilights of the mind into which other ages have been careful not to venture. There is no doubt either that this period is fast coming to a close, killed by its neglect of the more architectural and static side of art.

Two historical apologues best sum up the two main approaches to art: old master Sesshou in his old age decided to paint an aesthetic testament, a microcosm of the world of thoughts, philosophy, and technical experience, the fruit of seventy years of glorious labor. He took a feather, broke its quill, and dipping its barbs in ink made a splash on silk which up to now, duly authenticated by his own and many scholars' writing, remains the masterpiece of Japanese painting.

The Pope, in want of the best man to decorate his palace, sent learned emissaries to prominent artists to wring from each a major work proving his skill and knowledge. The winner of this contest was Giotto, who by tracing freehand a nakedly perfect circle, got the Pope's praise and the job.

To the student, emotion and geometry seem at first sight incompatible; yet they are but two facets of the one art. Underlying all emotional painting, even unknown to the painter, is a system of co-ordinates through which rhythms and spaces could be translated into figures as mathematical as are the intervals of music. And the

work of the architectural painter—does it not use the extremes of the imagination, the geometrical figures that look like nothing much around us? And the assembling of these elements, how much stamped it is by sensitiveness!

Bitter feuds of schools are good only for pupils who through the narrow door of technique search for the fields of the mind, but in the world of the masters, which is this world of the mind, there remains only harmony. There Sesshou's supreme splash connects without effort and abides easily within the perfect circle of Giotto.

17. PINNING BUTTERFLIES

(MATISSE VS. BARNES)

IT IS refreshing to find a book on Matisse that expresses an honest opinion, not a blurb rehashed from the enthusiastic prophecies of those who discovered Matisse when he was a young man.

One can readily agree with Dr. Barnes' estimate that the artist is "great enough to sustain comparison with all but the greatest masters", but how he arrived at such a conclusion is something his book does not make clear. Perhaps he and his methods have grasped in Matisse's 'œuvre' all that science can grasp—which is amazingly little. The descriptions of pictures which fill four-fifths of the book are as painstakingly accurate as the anatomical charts, followed by measurements in inches, intended to describe beauty-contest winners and prize-fighters, but the essence of beauty, or of strength, must lie in more hidden springs, since it remains undetected by such mathematical sleuthing.

Science can readily measure the size and grain of a canvas or the direction and breadth of a brush stroke, but a painting in a dark room retains its distinct physical existence— yet cannot be said to function as a painting. Its true existence is optical, it lives only as an image created in the brain of the onlooker. This optical and, so to speak, spiritual entity is already less open to scientific investigation, since

much depends on the personality of the witness. A dog will connect only with the pigment as it lies on the canvas. An untrained human eye may go so far as to perceive the subject matter and the degree of faithfulness to the model. A pedant will go hunting for stylistic influences, while for the trained eye and sensitive brain the same work of art may open vistas of simple delight.

There is much in this book about pigment and much concerning the history of art but, whether from shyness of indulging in what he calls "gusts of irrelevant emotions" or from plain toughness of the eye, the author says little that could make us commune with the peace and plenty that Matisse's masterpieces suggest. In spite of its imposing array of archaeological references and its home-made terminology, it becomes evident that the scientific method of Dr. Barnes cannot perceive further than Dr. Barnes' eye.

We can well believe the author when he reminds us that Matisse is a man of the nineteenth century, that he shares the creed of the men of the 'nineties, is influenced by Japanese

prints, then in their prime, trails somewhat behind the symbolist group of Pont-Aven, and, of course, bridges the century over Cézanne. But when we are told that Matisse is possessed of an "avid intellectual curiosity which makes him explore ALL the traditions of art of ALL periods", it is time to prick up our ears. Dr. Barnes refers specifically to Byzantine mosaics, Persian tiles and miniatures, Egyptian fabrics, Chinese frescoes, early Greek drawings, Negro sculpture, Egypto-Roman portraits, and to the work of fourteen painters which Matisse artfully plundered. Such a pragmatic knowledge of history and geography in a Frenchman—and, at that, a painter—is hardly credible, especially after rereading what Matisse himself wrote, that the artist "must sincerely believe that he has only painted what he has seen".

It may be that Dr. Barnes belittles the imposing influence of Nature in a painter's formation. Neither Byzantines nor Coptics nor Negroes were wilful stylists. Nature struck them in such of her aspects as are most akin to their gifts. This same objective world is the treasure chest from which Matisse extracts his own

forms. This and the repetitions of technique are enough to account for many resemblances.

Perhaps the most dangerous affirmation concerning the artist in question is the oft-repeated one that his interests are primarily decorative. To emphasize this decorative quality, the book suggests that he weakens or even suppresses the spatial values of his model so that "flatness is the rule in the great majority of Matisse's designs". The pictures thus duly flattened, Dr. Barnes proceeds to divide them into types according to their resemblances to flags, posters, cretonnes, tapestries, geographical maps, the fabric of gowns or of upholstery. It is true that Matisse uses but sparingly of those more obvious means of creating volume and space, chiaroscuro and the atmospheric degradation of tone, yet space is the all-dominant factor of his paintings which definitely distinguishes them from the objects listed above. In his own plastic vocabulary, the slightest modification of a color, even a change in the direction of a brush stroke, will round a fruit or a shoulder convincingly. The bands and stripes that are his most obvious theme, if they were taken at their

face value, would make his pictures little more than the flag or the poster to which Dr. Barnes alludes, but he uses them only as a means to create space and light. In his hands they become surveyor's stakes which emphasize the three dimensions of his painted space and coordinate the objects in the box-like formation that most of his pictures present.

So literally physical is Dr. Barnes' approach to painting that it seems at times as if food were his theme. He revels in the "juicy" impasto of Soutine and shrinks before the "dry, dull, arid, unappealing" surface quality of Matisse's paint, although such a surface fits eminently the kind of metaphysical balance that characterizes the best of his work.

In his drawings, as in his sculpture, Matisse bares the deep human emotion that in the Nice oils he so politely dilutes. But their lack of analyzable props and, moreover, their psychological flavor make them difficult for Dr. Barnes to label, and it is with relief that he comes back to the bands and stripes and rosettes that for him seem the essential Matisse.

To think "Matisse" in the abstract, as

we may think "Ingres" or "Delacroix", brings to most minds a mental, rather than a physical, image. Nor does it conjure quite as clear a mood as those two names do; rather does it suggest a dual personality. In the heroic pictures of the Fauve period, in which he perhaps reached his loftiest climax the sobriety and monumentality strike a monastic note not far removed from Giotto.

Then occurred a breach, a relaxation of the inner tension, which transformed Matisse-the-Fauve into the supple and well-bred Matisse of the Nice period. In those pictures the bourgeois and 'intime' feeling masquerades lightly under the trappings of Oriental bric-a-brac so dear to the heart of the Frenchman, who likes to travel at home, an Orient of the same brand as Molière's 'turqueries'. Those two notes, the heroic and the 'intime', sum up Matisse. Of the first one, the book does not speak, while the second, apart from its historical connotations, is alluded to in a footnote, very curtly, probably because the author felt he was here skirting the taboo subject of spirituality.

It may be that the book, much against its

158

author's aim, builds up a case FOR the literary
critics. Knowing the limitations of each me-
dium, they do not attempt the wearisome task
of duplicating in words the art object. "Scien-
tific" criticism, on the other hand, in its concern
with pigment and canvas, misses the spiritual
quantity of which pigment and canvas are
merely the hieroglyphics.

Eilshemius: "The Prim Soldier."☞

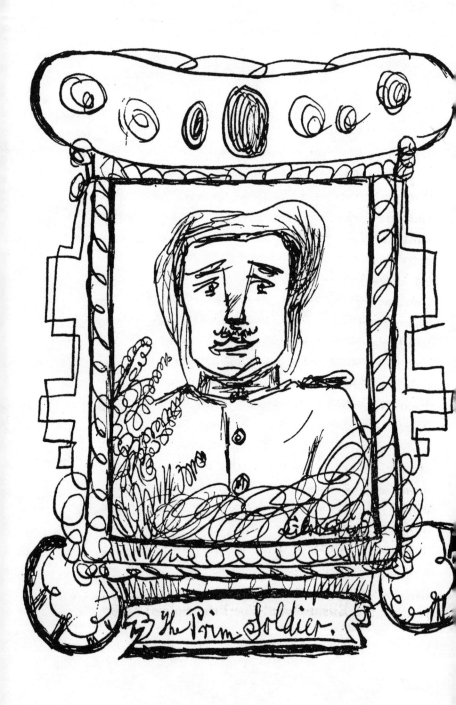

The Prim Soldier.

18. LOUIS M. EILSHEMIUS

THE paintings of Eilshemius are laughable,
that is, they have been laughed at so heartily
that it takes courage to realize and confess
with the unavoidable blush that he is the great-
est American painter of his generation. Yet
there was good ground for laughing. Eilshemius
was no man of mystery. Known to all dealers,
to all painters and critics for decades, and not
one to think much of him or his work. So his
paintings accumulated right where he lived, on
East 57th Street, the hub of the art market.
Not in the hands of dealers, of course, but in
his own house, stacked behind sofas and wash-
stands, in his cellar, in his attic, well varnished
under a coat of dust. Year after year the pile
would grow, strata upon strata, with almost
undisturbed geological precision.

For all of this long time Eilshemius was the
only one to believe in his work. He would pub-
lish in print this faith, force his copy on re-
luctant art editors. For the public, misunder-

stood geniuses lose interest if, first and above all, they do not misunderstand themselves. That a Van Gogh died in full consciousness of his genius is indeed a thought to make one uneasy. But at least Van Gogh was discreet about it, his brother being the only one to share his secret. Eilshemius wanted to take the whole world as witness and thus, paradoxically, brought himself to a state of the most public isolation.

The pictures themselves are, even now that all agree on their goodness, rather difficult to forgive. We pride ourselves on sophistication and nature seems to us very poor art indeed. But not only do the paintings of Eilshemius look like nature, but like nature at its worst, when its sunsets and moonlights, lakes and ladies and gondolas remind one of artistic picture postcards or of the gilded and embossed design on a Cuban cigar box.

These are the odds. Grave as they may be on social grounds, it is evident that, aesthetically, they are not even blemishes. There have been good artists who knew they were good and said so, and taste is rather in inverse ratio to greatness. Whistler had good taste. But the very

great have great innocence and fall more easily
into social errors. Witness the Turkish Bath of
Monsieur Ingres or the daubs of that other vul-
garian, Courbet. Because the good artist real-
izes shamelessly whatever his inner impulse bids
him do. Of the critics, the public, he does not
think. His struggles, his victories, are strictly
fought and won in isolation. In not one of
Eilshemius' pictures is there a hint or knowl-
edge that he will not be the only one to look at
them, none of that slight stiffening of the back-
bone of the man who knows he is being watched.

The freshness and clarity of his early land-
scapes are little short of a miracle when one
thinks of the bitumen-loaded brush of his con-
temporaries. Among the best are souvenirs of
his trip to the South Seas. The king and his
family, and many native beauties, were painted
with all the intimate seriousness with which one
would paint his friends and parents. Later on
Eilshemius indulges in more fantastic subjects,
be they nymphs monkeying in moon-lit forests
or ghostly riders under majestic clouds, they
all obey the same sweeping joyful rhythms of
his spiritual maturity.

The technical resolutions always inventively genuine are of the greatest simplicity. The atmospheres, laid thin, vanish into layers of space with the airy nobility of a Lorrain, upon which foliages are spattered with the craft and zest of a house painter or a Dosso Dossi. The textures are contrived with new physical means; I remember some donkeys with all their hair engraved in pencil on the thick impasto. Figures well into the distance, acquire, when you get closer to them, a wealth of details that do not somehow intrude on the whole. They are, as their author puts it in a fit of pride, as truthful and complete as a photograph. It is true that a picture by Eilshemius is not any more paint on canvas, but admits you from the start into its three-dimensional reality.

This belief in an outer world, in the existence of the object, is the proof of a good mental health even if it belies the actual trend of art-philosophy. Painting being optic and optic dealing with bodies, bodies in function of light, as Poussin has it—the more objects, the more details in those objects, the more painting you will have in your picture. Not that Eilshemius

finds any problem at all in the representation of objects; they all come to the tip of his brush; the trees, the water, the nymphs, the mountains, as swiftly as the rabbit from the magician's hat. Yet in spite of the story telling, the illustrative quality which he relishes, his pictures are endowed with a spiritual animation that far outweighs their realism. His models, often trivial, are made by the alchemy of genius to give utterances deep if disconnected with their everydayness. I recall a picture now in the Phillips Memorial Gallery called "The Rejected Suitor". A gentleman in a brown derby, some Victorian ladies amidst furniture to match. The artist had swallowed it whole, bustles, gilt and plush, without a hint at discrimination or fun-poking. Yet it was impossible to escape the sense of mystery, subdued and subtle, that permeated it, reminding one of Vermeer and Rembrandt.

Historically, Eilshemius, like Rousseau, is a freak. Which means that it is hard for art critics to make him fall in line. Possessed of the cocksure craftsmanship of a Magnasco or a Dufy he ought to be, on technical grounds,

classified beside such examples of subtle deca-
dence. But the art of those virtuosi, humorous
or exquisite as it may be, is somewhat shallow
in spiritual content. On the contrary, the work
of Eilshemius, though dressed up in similar
garb, is all permeated by a spirit of childish
innocence, of wonderment before the beauties
of the world, a spirit to be described by the
word 'primitive'.

If the history of art does not yield readily
to include Eilshemius, much less will the history
of today. Unmistakably, the gargantuan good
health with which he succeeds in recreating a
whole world with ease, does brand our painter
as unfashionable. The giants of modern art,
battling forever with a guitar, the ripping feats
of a Picasso in humbling the human machine,
bring us more readily to our knees. But an art-
ist paints more often for the future generations
than his own, and Eilshemius can afford to wait.
His pictures exhumed, soaped, scrubbed and
framed, are at last in the hands of an intelli-
gent dealer. They are well revered by the young-
est of art students who puzzle already at the
fundamental distrust and discomfort that na-

ture gave to their elders, and feel somewhat
distracted in the presence of abstractions. They
look back for guidance to those masters of yes-
terday whose realism and craftsmanship they
relish. Their cruel and pious hands, to make
place for Picasso, take down the shelves and
dust tenderly the somewhat bruised busts of
Gérôme and Bouguereau. In the days to come,
much emphasis will be laid upon objective ren-
dering and technical excellence. By then, the
art of Eilshemius, blending such qualities with
those of the spirit, may be a useful reminder
that after all, and however real paint may look,
"la pittura e cosa mentale".

19. EDWARD WESTON

By DEFINITION photography is a most objective medium. By vocation, Edward Weston makes it more so. To survey chronologically his 'œuvre' is to witness a purposeful shelling away of subjective addenda, of trimmings that, to the average observer, transform a photograph into a work of art.

In his earliest work, lyrical qualities strive to express themselves against the logic of the camera. He idealizes objects through 'flou' effects or spider webs of shadows, much as a French chef will induce a fish to look like a chicken and taste nearly as it looks. Those trickeries soon discarded, Weston tried to retain a well-earned right to unusual photographic angles, subtle space composition and sophisticated layouts. It seems that, without such pride feeders, an artist's personality would cease to be. But his destiny was to strip himself still further. In his present work, the last vestiges of self-obsession have disappeared. In the

concrete, implacable way which is its own privilege, the camera records whatever it is, rock, plant or trunk, that Weston innocently squares plumb in the middle of the lens.

The increased effacement of the man behind the machine has resulted in deepening and heightening the aesthetic message. With a humbleness born of conviction, the artist distracts our attention from himself as a spectacle, shifts it to nature as a spectacle. The search for a super-objectivity produces an art which accomplishes the inner aim of all great art, to make us commune with the artist's clairvoyance in the minute of creation.

This application of the apologue of the man who found himself by losing himself clashes with this epoch of artistic theorizing. People now profess that objective vision and subjective understanding are incompatible, that the former is trash compared with the latter. Yet man speaks but of himself: however objective his aim, he does not describe objects, but only his own sensuous contact with them. The more tenaciously a painter clings to normal vision, the more clearly will he state, as does Vermeer,

that the human optic is a more perfect means of emotion than of cognizance. The camera too gives us not the object, but a sign for it written in terms of light and dark, often at odds with the experience gathered through touch, smell, mental knowledge or even an average eye. As concerns the supposed hierarchy between an inner and an outer world, let us remember that the only possible commerce of the optical arts is within the realm of the visible, deals with the description of physical bodies. This does not mean that art must be de-spiritualized. The very fact of the visibility of the outer world is proof that it has laws, rhythms and phrases to which, both being attuned to the same diapason, the laws, rhythms and phrases of our spiritual world answer. To describe physical biological phenomena, erosion, growth, etc., is to refer to similar happenings in our mental world. There is a mystery in the objective realm as loaded with meaning as are the voyages that one makes into oneself. Weston has understood those things as few others have. More exactly, as artists—at least in the heat of creation— do not think, Weston has lived these things.

The more objective he strives to be, the more inner chords he strikes, and in so doing, points to a means of liberation for his fellow artists, away from the current and exasperating creed.

There is nothing in his photographs to enthuse the kind of aesthete who expects from art the same soothing or tickling that one demands from an ivory scratcher. Poussin justly stated "the aim of art is dilection", but many mistake pleasure for dilection. Superseding the physical, and even the emotional, true dilection is of the realm of the spirit.

The physical exertion inherent to the technique of painting, the multiple twists of arm, wrist and fingers, as well as the time that goes into the creation of a picture, are too often deemed the standards of its excellency. Yet they often result in a muddling of the mental image that the painter forms at the start, and then patiently mutilates. The Chinese understood better this fact that physical exertion is incompatible with the highest forms of meditation; their greatest masterpieces, devoid of color, jugglery or patience, were created in five minutes with a broken reed, a feather, or a finger

smeared in ink.

Weston's art is a culmination of the Oriental concept. Hand and wrist work give way to the mastery of the machine, eliminating such uncertainties as are corollaries of muscle and time. Under the stupendous concentration of the artist's mind, 1/35 of a second suffices to create an image with which to perpetuate his spiritual passion.

Weston's world of ordered bodies is as fitted a tool towards contemplation as the hierarchy of blacks in the greatest ink paintings—with this added security, that Nature being actually such as revealed in his well focused photographs, we come closer to the mechanical proof of its being, in essence, divine.

Shore: "Canadian Weed." ☞

20. HENRIETTA SHORE

HENRIETTA SHORE is a painter upon whom a curse of indifference rests heavily. Amidst the void created, her work has grown manful and sturdy as it would not have in more hospitable surroundings. This bitter protective shield is the fact that she is classified as a decorative artist. That more than many she has worked, loved and suffered, that she buttresses each stroke with a full impact of brain and heart, does not weigh in the balance against the fact that she is a woman, that she paints flowers, and that her technique is crystal clean.

A decorative artist is one who uses nature as if it were an inferior putty out of which to make daintier things. But artists of Shore's type feel small and helpless when confronted with the Creation. Nature in its manifold manifestations appears to them so admirable that they cling tenaciously to any part of it, be it a blade of grass, in order to partake of its hierarchical wisdom. To such artists, it seems a negative

feat to transform a mountain into a triangle or a living flower into an arabesque. Today, their passion is matched by that of the microphotographic lens which uncovers Greek capitals in a bamboo knot, or Gothic vaults in a thistle head.

The cogs of a watch in movement may be appreciated in abstract, as a delightful concordancy of circular lines. More imposing is the sight of the living intercourse of axles and wheels, and even more to the point if one does not lose sight of the fact that a watch marks time. All objects in nature can thus be projected in two dimensions, leaving a deposit of lines and colors, or viewed in space as mechanical arrangements, but only great artists, true to their belief that the world is oriented, present natural facts as corollaries to their spiritual use. They thus relate otherwise unrelated objects, spur and help the onlooker at the process of unifying his own world.

A popular belief concerning 'geniuses' is that they slash the canvas with disheveled strokes, are partial to dazzling lights and deep shadows. Men like Grünewald, Van der Wey-

den, Pontormo belie the saying, by expressing passion with careful line, clear color and the smoothest of techniques. Modern art has been spare of men of this type. Henrietta Shore, who years ago forsook ability for better things, chose to become the impeccable craftsman of her own passion. Hers being not an invertebrate emotion to be fulfilled in a sketch, but the belief that nature, ordered and meaningful to the utmost detail, deserves to be transmuted into paint with equal care.

Her evolution of means achieves autonomy through a desire for self-effacement. Her technique is exacting; she will work for days on a linear draft until it acquires the supple inexorability of the copper ribbon that partitions cloisonné enamels. Modelling and local tone imbed themselves in these boundaries as logically and organically as muscles and tendons to bones. Supremely aware that colors *per se* are of variable densities and endowed with personal spatial co-efficients, she mixes and applies them with the vital care of a druggist compounding a prescription. A small area becomes dominant when tuned to red or yellow; rainbow-

like blends make the plane recede or advance, cave or bulge. The finished picture, though coinciding with the first draft, is plastically and emotionally a new work. It possesses a smooth finish and a stencil-like accuracy. The absence of visible brush stroke, the rigid emphasis on local colors, a diffusion of light through which modelling acquires a quasi-static content, those rare elements are in close kinship to older and perhaps saner art periods than ours, when the artist, having things to say that he believed of public interest, was proud to do so with grammatical clarity.

The resulting finality of her designs rebukes and misleads her contemporaries. Most modern pictures are suggestions on canvas, to be glozed over at will by the onlooker. Critics delight at this 'jeu d'esprit' but, unpolitically enough, Shore gives in each picture premises and conclusions, with such forceful style and detailed particulars that the baffled critic cannot find his cue.

Though the spiritual climate which sums up a great artist's achievement is gathered through the autographic confession of line and color,

his choice of subject matter helps clarify his stand. The world of Shore is made peculiar by an absence of anthropomorphic delusion. In this world of rocks, birds and flowers, man and man's moods play little part. Her trees need not ape human gestures to be significant, nor her flowers a corsage. Rather does she subject the few humans she portrays to laws of vegetable growth and mineral erosion.

Keenly aware of the chasm between appearance and essence, she connects with her subject by the roots. When she has mastered a natural law by meditation, she proceeds with the logic with which stem, leaves and flowers unfurl from a seed. To attain such true realism, Shore looks long at her model but conscientiously turns her back on it at the time of painting.

21. FRANKLIN C. WATKINS

TRIED and true men acting on juries are seldom expected to render judgements as drastically upsetting for established values as those of which we will be the abashed witnesses on the day of the Last Judgement. Yet such an incident happened when a Carnegie jury in 1931 gave to Franklin D. Watkins, unknown American, the first prize at the Pittsburgh International. It was of course blamed on cocktails, but there is reason to believe that this judgement will hold good for some centuries to come.

The net result was that on two or three further occasions in which he publicly exhibited, Watkins was a ready target for the bitter denunciation of well-meaning critics. They especially attempted the sabotage of his grandiose mural, "Man Crushed by the Machine", a humanistic work that linked him through Delacroix to the great Venetians, reminding one forcibly of Tintoretto.

Watkins: drawing.

This is the trouble with Watkins; he is a necromantic painter, whose familiarity with the Dead makes the good neighbors suspicious. Engrossed in his own pursuits, he does not try and emulate the white horses of the art galleries, forgets to take part in the hurried confabs and huddles from which new-fangled movements emerge. Watkins, nearing forty, has not yet had a one-man show.* He works with the utmost hesitancy, destroys or hides most of his work, apologizing profusely for the bare dozen pictures that he dares to show at all.

This humility is of course born of pride; but it is true also that all his painting may be said to be unfinished in as much as the life that permeates them makes them ever shifting; they will never become static, resign themselves to being a decorative scroll, or a self-contained volume.

Whatever the actual subject matter, the permanent presence in his pictures, the dramatic actor, is the atmosphere. It is the common denominator that links all things together. Its bulk measures space, it defines the shape by contact, and the movement by its own resistancy. In this painted world things never exist

* This was written in 1934.

in themselves, as museum pieces in a show-case, but mixed and intermingled and related. The bodies Watkins depicts acquire a kind of elastic consistency, they are in the ectoplasm stage where shape is dependent on movement. His is a very complete world indeed where the credibility of movement strengthens in turn the idea of space and implies the existence of time.

This peculiar philosophy too relative for sculpture, too didactic for music, is eminently suited to the medium of paint. Watkins shuns the sculpturesque definition of volume through black and white, suggests it through imperceptible transitions of value from color to color. The eye, while it absorbs the volume, never loses contact with the color sensation.

However articulate his grammar, Watkins does not delight in it, but uses it soberly as a tool. The message he wishes to carry to the onlooker is not that of a good painter, but primarily that of a man of passion. The mood is as pre-eminent in his paintings as it is in lyric poetry. And it is this mood which grasps and disintegrates the subject to serve its own human aim as completely, but more beautifully, than

the impressionistic light immolated the subject to scientific superstition. In his "Blues" the negro is recreated from within, endowed with a syncopated body, the whole dark scheme being miraculously suggested by cream and buff and white. In another paradox, "A Lady Holding Flowers", a daemonic mood transforms a Victorian bodice and bouquet into the repellent spikes of some tropical fish. Or he tackles the problem of man in relation to the universe in his "Boy" so studious, dwarfed by a hypertrophied background as is a Chinese sage by a towering abyss.

Few terms of the aesthetic jargon in vogue could fit at all a description of Watkins' paintings, so removed are his aims and means from the orthodox modern path. The good artist of today builds up with paint an organism with members as carefully interjoined as are the cogs of a machine. His naïve assumption being that such a body will somehow suscitate its own soul. But the miracle more often fails to happen and the picture remains a most complete corpse. Watkins uses an opposite method, somehow more sound in its inception. He builds

up a spiritual core which when strong enough
accretes its own body. This metaphysical qual-
ity of his work has repelled most of the critics
who have spoken of him. They point to the fact
that he is not an architectural painter, and thus
unfit for murals. Watkins is certainly not a
fresco painter, yet he proved himself a mural
painter of the first order both in the panel
shown with such negative success at the Museum
of Modern Art, and in the huge godly Hand
that he still keeps in his studio. His mature
philosophy, even though embodied into quasi-
impalpable modulations of color, could give any
wall an architectural strength unequalled by all
the make-believe robots of his more 'construc-
tive' colleagues.

Shahn: "Portrait." ☞

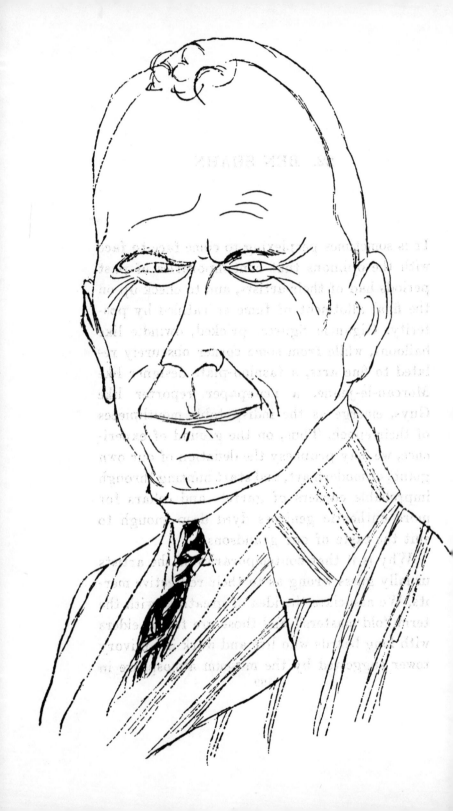

22. BEN SHAHN

IT IS sometimes perplexing to come face to face with the opinions that contemporaries of past periods had of their artists, and to check up on the final allotment of fame as ratified by posterity. Gigantic figures, pricked, dwindle like balloons, while from some corner obscurely related to fine arts, a fashion-plate designer like Moreau-le-jeune, a newspaper reporter like Guys, emerge as the indisputable mouthpieces of their epoch. Thus, on the ground of experience, we may prophesy the deflation of our own giants of modern art, and start hunting through improbable corners of garrets and cellars for more authentic geniuses dyed deep enough to suit the taste of our grandsons.

Why is it that contemporaries of the artists usually guess wrong as to their respective merits. We associate the idea of greatness with the term "old masters" and those are for us elders with long beards who live and work in an ivory tower suggested by the museum atmosphere in

which their pictures are now buried. We forget
that those old masters were young, and that
they achieved international fame only by cling-
ing tenaciously to their own earthly boundaries
and mental idiosyncrasies. Thus Brueghel, after
a trip to Italy at the time that Michelangelo
was painting the Sistine, came back home
steeped deeper than ever in the atmosphere of
his own Dutch peasantry and his distaste for
the Spanish invaders. Siding with one's own
moment, country, party or hamlet, diving into
the social turmoil, using pencil and brushes to
club your opponents is paradoxically one of the
surest ways to remain in posterity's conscious-
ness as a master whose work transcended all
limitations of time and space.

We can safely look at Ben Shahn as a most
valuable witness of our epoch. Both his lan-
guage and subject matter are unmistakably
contemporary. He is indeed a painter of his-
torical tableaux as much as Emmanuel Leutze
or the Baron Gros, and if his pictures are so
dissimilar from theirs, it is further proof of
how genuinely Shahn is of his time. The sources
of Shahn's art, that is, the technical sources,

its grammar, are to be found in this school of Paris whose aims differed so entirely from his own. Flippant Dufy and Catholic Rouault contributed indirectly to his vocabulary those broad washes of gouache which in an apparently accidental way create the volumes, but not this tense, grimy city atmosphere which remains peculiarly his. On this loosely brushed background a line as keen as the sharpest silverpoint superposes its own version of the subject, sometimes in agreement with the mass modelling, but more often unbinding itself from it and creating a version of its own. It is a palimpsest, two texts perceived simultaneously, whose concordancies and discrepancies create a third image, forcefully dynamic, which is the picture.

Much of Shahn's style is explainable by his aims. Being a story-teller, his source material consists mainly of newspaper reports, his models being the photographs of rotogravure sections and tabloid sheets. Degas also used photographs, but purified, stylized, lifted to the plane of his art. Shahn, on the contrary, delights in what is peculiarly accidental, cynical, and ungentlemanly in camera work. The gym-

nastics of inhibition by which we immediately substitute for any given spectacle a more anthropomorphic version in which hands and heads will be given the leading role, do not fool the camera, nor Shahn. For them a man, however intellectually eminent, will exist mainly through the bunch of folds and creases, which are his clothes, his buttons, his shoe-laces, his grotesque shadow on a brick wall, the baroque mouldings on the arm of his chair, while his mouth and eyes may be summed up in three inconspicuous slits. Such an ousting of our lawful vision is a slap to the highly orderly and satisfying implications that this vision symbolizes. Yet the more one grows accustomed to this new version of the world, the more one is able to perceive in it a new order. The overgrown canine teeth of Governor Rolph, the bittersweet dimple at the corner of Mooney's mouth are enough to reassure one that this apparently mechanical vision is as heavily loaded with moral values as the more conservative and antiquated version.

23. CUBISM: REQUIESCAT IN PACE

FASHIONS as they recede in time pass through many qualifying trials before they settle into the perpetually pink light of the dear old past. The most trying moment comes when they are far enough from us to be out of style yet close enough to lack mystery, for we still remember that mother dressed so and that we ourselves used to be thus dolled up as babies. If art were wholly fashion, cubism would therefore be at its lowest ebb now, with cubist pictures piled into ash cans along with the hats of 1915. The impressionist picture is altogether a museum piece, but so are the bustles and "suivez-moi, monsieur" of its generation. Surrealism is so up-to-date as to be the guiding spirit behind shop-window displays. Cubism, hemmed in between them and stripped of all glamor, will indeed need undying qualities, the peer of those of the great schools of art, if at this stage it is to pass through the narrow door of the museum, where neither fashion nor history can vouch for it.

Cubism is still alive, still worshipped, but rather doting. The new-fangled approach to art, irrational, emotional, has permeated the classical structure. Cubism still struts along with the younger fashions, claims surrealist tendencies, but those are rather the worm in the fruit than the feather on the cap. To treat of cubism at its noblest we should limit ourselves to its brown period—1910–1920—when it genuinely pioneered, was serious, constrained even, had no time or taste for the fantastic. Cubism as a discipline of reason is the movement at its most genuine—an impersonal homogeneous art that could have reigned over a unified world with the autocracy of a Le Brun or a David. Cubism has at least succeeded in achieving a dictatorship in the realm of the applied arts. We live in a world streamlined as the cubist helped to create it. Duly grateful for its achievements we should interr cubism in History with loving care. This article is intended as its respectful eulogy.

A painting is of course a flat rectangular plane if we describe it as a physical object. But since line and color create illusive space it

☞Picasso: Detail from an etching.

is nearer to optical truth, even if a departure from factual truth, to compare a painting with a box, lying on its side, its opening coincident with the picture proper. This box is also a minute stage which up to the time of the impressionists had been filled with an assortment of stage-flats whose carefully receding planes helped to carry the eye to a backdrop. The impressionists' dubious novelty radically changed this notion of a limited space trimmed into the layout of a stage. They knocked out the back of the box, and thus exposed whatever natural disorder—trees, skies, haystacks—happened to be behind it. But by making space limitless the impressionist at the same time weakened its esthetic value. The somewhat quaint arrange- ments of the past had brought recessions from flat to flat into mathematical relationship, had played upon spatial intervals as one plays upon musical intervals. But this could happen only when all the distances involved were measurable and comparable with each other. The infinite space of the impressionist became a joker in the game, for you cannot behold, divide or compare the infinite. Intended as an improvement on the

finite, it greatly impaired instead the whole structure of art. Cubism's most important step was to nail back into place the discarded back of the box. That Cubism filled the box with solids in a somewhat over-zealous way until it looked like a packed croquet-box does not alter the great achievement. Sobered by the impressionist binge into space the cubist dropped horizons to play with blocks; but blocks are measurable, comparable, and as such are fit units for creating exact beauty.

Impressionism, proud of its knowledge that painting's reason for being lies in the mental image it creates, is somewhat unkind to the painting as an object. It forces the spectator away from the painting, blurs his vision at close range until by stepping backwards to focus properly his more than arm-length range hinders him from finding a tactile correlation to what his eye sees. The impressionist wants his painting to become a mirage, a protoplasmic entity that the frame limits only uncertainly. The cubist, opposed to his father's ways, gathers unto himself the physical picture—the tight drum made of canvas stretched on a wooden

scaffolding; rather despising optical values he insists on tactile values—not illusive ones either but good sandpaper or corrugated board pasted on the picture. The fluffy contours that dissolve into air give place to honest lines stiffened after the ways of ruler and compass. Cubism, utterly weary of color, that treacherous element which makes a Monet out of a picture when you don't watch, safely limits itself to a tobacco-juice brown, snatched while still fresh from the palette of the academic painter. The four edges of the canvas, disdained by the impressionist, become dictatorial under the new order; the web of lines they imprison derives from them proportion, direction, the angularity of the inner design. In the same way the optical box or stage forces all the solids within its walls to ape its architecture: it becomes the paragon of all the cubes to be found in cubism.

There is a great nobility in this hunger for chains. This acknowledgment of limits is not only heroic but classic. And this discipline has received a fitting reward: the nut-brown aura which haloes the cubist picture turns it into a museum-piece before its time; to this day leaves

the benighted amateur highly respectful if slightly bored. It is also appropriate to this classic vein that personality was taboo in those early days and that Braque and Picasso did not blush if they misnamed each other's pictures. Because the painting was considered mainly as an object the painter became a kind of tradesman rather than a superman. Each cult must have its idols, and the impressionist had enshrined Turner. It is characteristic of the cubist that he should enthrone the house painter rather than any one master. This workman could lay a tone flat, freed from the tremolo of Monet. He was a sound technician and used two thin coats of pigment rather than one fat one bound to crack. His subdued palette was careful of the retina. When he traced straight lines he used a ruler; when he traced fancy lines he pushed the paint through a stencil. Confiding in mechanical means, he escaped the narcissist attitude of the impressionist whose own wrist and eye were his gods. The cubist also hailed the sign painter as great, for among the infinite combination of lines that we may use, letters are the most spiritual, their mental content

having drained them forever of any sensual connotation. Each letter is a masterpiece of design, better attained by mathematical computation with compass and ruler than by improvisation. Letters were so suitable to the cubist ideal that the painter spattered A's, O's and E's over his picture with a zest similar to that of a Monet juggling with sunbeams. The master cubist, distrusting his hand (which verily was not as well trained as that of the sign painter), preferred scissors and paste-pot to the brush. Fragments of newspapers embellish his picture, for what freehand version could match the beautiful impersonality of the printer's product. In this same vein of common sense Fernand Leger exalted the show windows of haberdashers and hatters as masterpieces of composition—not the expensive shops which employ artists and extraneous material to round up the effect but those in which the small shopkeeper presents ties, hats and shirts in rigid ranks of solids spaced with care.

But though the painter, dropping beret and beard and endorsing overalls, prided himself on being a working man, though he built his pic-

ture with as much physical soundness as if it were a chair or a table, the picture refused to play this soothing game—to become, as the painter wished it to become, a common-sense object. In fact the cubist picture became a slightly more puzzling object than the impressionist one. The latter had educated people to a kind of vision which had become second nature. The eye and the brain had become exquisitely disconnected. One dared not swear to the roundness of a tree trunk, the cubicalness of a house, but things rippled amorphously into nothing, the world at large was camouflaged under the sheen of a Harlequin's coat of blue shadows and yellow lights. The cubist's job was to switch on the current again between brain and eye, between what one saw and what one knew; to bring mental help to the eye which had grown hypertrophied, had run amok as if possessing an animal life of its own.

We learn from the writings of Raphael that he painted not so much from the model as from a vision or pattern which existed in his mind only, and that this vision was of a circular kind. And the more beautiful the madonnas he

created the more are they unlike the women we elbow. The bulk of their features and of their hair weakens, flattens itself onto the larger volume of the skull, until the head perceptibly glorifies itself into a sphere. In Ingres, who drank deep of Raphael, we have rubber-like arms, necks and joints in which the bones soften to give way to cylindrical beauty. The shoulder and bosom lines lose their substance to become the trails of great arcs of circles whose movement would not be responsive to each ripple of fabric or muscle. In Seurat we have archaic bodies which swell or narrow equally round, irrelevant of how nature may wish it. They are related to the Nuremberg toys of turned wood, to the legs of chairs and to Ionic columns rather than to the science of the anatomist or to the optical blandness of the photographer. Those masters could conceive such sights only when the connection between eyes and brain had been so clarified and strengthened that the brain could give orders to nature—which the eye, a kibitzer, beholds overgrown with parasitic débris.

The cubist came back to the classical ap-

proach, the intellectual vision articulate as a well-balanced phrase, in contrast to the impressionist's vision which is more in the nature of an exclamation or an intaking of breath. When at the click of his eyelid Monet's wrist started to work, his brush did little but record what was before his eye. Lured by the accidental he could not elevate his art to the generic. Intellectual vision treats of genus and type, lowers itself to individual examples with effort. How often, in portraits of men painted by the classic Renoir, we feel that by tearing off the trick moustaches and beards, prying open the collars, we shall uncover his rotund feminine paragon, the Gabrielle who was not his cook at all, whatever history tells us, but rather a type whose origin existed in this artist's own mind—a type which his earthly models reflected more or less but all imperfectly. As with Raphael or Renoir, Picasso's vision tends to general concepts. The square bottle which he paints is more than a particular bottle, for by whirling around its axis it establishes a void into which all bottles —of whatever profile, lip or belly—may be fitted.

Cubism by putting brainwork back into vision infuriated people—and who knows if it was a blessing to tear them away from their sunsets and their rainbows of lyrical moods. After all we know that houses are cubes and that skulls are egg-shaped; and as an escape from facts what is more tempting than to stand on our heads and look at scrambled reflections in the water and make believe that this omelette is a dream-world.

The eye, Monet's god, became with the cubists an invalid that had to be handled firmly if gently. Making their own Félibien's saying (1670) that the eye is easily deceived, they brought aids to the eye to correct its mirage. Something is hazy and shimmers in the sun. Come, pass your fingers over its surface, feel its hardness, its smoothness or roughness, such qualities as remain true even in the dark. You see a table with its sides running back to a horizon line, its farther side smaller than its frontal. Stop looking, correct this mistake by measuring each side and see that they are all equal; use a square and understand that all angles meet at 90 degrees even though your eye fancies

them acute or obtuse. Italian perspective and its bastard son, the academic style, had immobilized the spectator into a single point of view, had even bade him close an eye so as not to be disturbed by twin images. Cubism took the spectator out of his cramped position at this peephole, recognized the fact that man has two eyes. Many of those idiosyncrasies at which Cézanne's critics scoff—tables that disappear behind a bottle to reappear at a different level or at cocky angles, cubic bodies that show their thickness on too many sides—are a simple acknowledgment of our binocular vision. The cubist, however, liberates and instructs the spectator further. He bids him shuffle his feet too, walk around the object and gather a variety of data to be memorized and superimposed in a composite glyph which stands for the object. The cubist makes the heads that we see full front unhinge themselves at the nose to exhibit their profile. Not only does the spectator walk; he flies to observe the lips of the bottle as a full circle, he burrows and the bottom of the glass becomes a circle too. The power to free man from the straightjacket and the eye-blinkers of

the academic vision, to transform the single point of view into the shifting one of an up-to-date movie camera, will excuse whatever coarseness may have marred the means.

The impressionist dabbled in astrology. The fragile dialogues between object and shadow which he loved to paint were at the mercy of celestial influences; his haystacks were the fingers of an ever-changing dial. Monet revolved, a minute planet himself, around his model, followed by his daughter pushing a wheelbarrow piled with canvases, one for each mood and fancy of his master, the sun. One is reminded of the apologue of the realist painter who, tackling a still life, achieved perfect duplicates of the marble chimney, the vases on both sides of the clock and the bronze statuette on top of it but was defeated throughout a lifetime by the dial whose hands he could not match.

The cubist broke this enslavement. He was forced to utilize light since it is the only means a painter has to reveal volume, but his light was not that of the sun. A diffused emanation, obedient to form, it bathed the object in inverse ratio to its distance from the picture plane. No

fancy beam played on his stage; shadows were as absent from his peculiar climate as they are in things seen in dream. The effect produced was akin to that obtained by chemical photography or infra-red rays in the dark. Though the impressionist was naive in his sun-worship, his open window will forever afford the layman good air. The cubist picture lives in a limbo where the seasons of the year, the time of day are forgotten.

The cubist's itch to put his hand on the object, to pat its angles and test out its texture with his cheek, brought the model under the painter's very nose or even nearer. Picasso, asked how he proceeded to paint fish, answered "First, I eat it." The veil of atmosphere, whose mystery had intoxicated the nature-lover of yore, was rent. The painter had become anatomist, dissecting guitar and bottle—the wood or glass here, the profile there, the elevation, the plan, the slice. Space had been the impressionists' subject matter. It had reduced the bones of trees and mountains to a jelly, had digested solids into a fog, had ebbed in and out of the picture like a breath. The cubist came to shun

space and lavished his care on volume. His was a world of solids unwilling to make place for skies and clouds. The breath of life, the throbbing which keeps impressionist painting alive, was unwelcome in the cubist limbo. Natural shapes were solidified into crystal forms—or rather, shunning the sheen of crystal, into those wooden models of cubes, cones and cylinders over which the musty aroma of the classroom shelf still hovers.

The cubist concept of the world was so close to that of the sculptor that he borrowed some of the sculptor's means. A painter's space is the emptiness which gathers around a volume from the outside. A sculptor's sense of space is no more than a gauging of the volume, similar to the innate awareness each of us has of his own body, traveling within the spaces of the skull, determining the capacity of the chest by the volume of air inhaled. This voyaging through matter is obligatory with the sculptor who cannot create more distance than lies between one corner of his marble block and the other. Though the painter can include the world, up to the horizon, in his canvas, the cubist limits himself

consciously to problems similar to those of the sculptor. But this concentration upon inner cubing, when applied to others than ourselves, comes close to the instinct of a ripper: it was not long till the cubist dismembered his models, exhibited piecemeal the fragments that constitute the whole, found the inventory of a body more exciting than its integrity.

The abandonment of visual means, however, had one superb advantage—that the artist got rid of the presence of the model. The sunlight and air which the man who painted landscapes inescapably absorbed were no doubt beneficial to his health but they had little connection with the painting trade. Whatever attention the painter gave his model was subtracted from the making of his picture. Painting as manual labor is a precise activity not unlike that of a druggist weighing and mixing the components of a prescription and as such requires concentration and quiet. I doubt that even a watchmaker could put together a watch in the open with the sun playing rainbows on his metals or with cows mooing and flies buzzing. No wonder the impressionist had to replace painting, as tradition

had known it, by a kind of shorthand, a hit-or-miss lack of technique that was the only possible approach under such improper conditions. At last, with the advent of cubism, the painter, accepting the making of a painting as his job, became the stay-at-home an artisan should be. He put his knapsack and folding seat to rest and pottered in the workshop. This was no innovation but a return to normal. Cennino relates that when the Giottesque wanted to paint a mountain he brought a stone to his studio and copied it at the desired scale. The cubist, a man of less faith, doubting that the mountain would come to him, compromised with common sense and chose to paint indoor objects—the pipe, the bottle, Cézanne's fruits and table. His was, of course, a partisan choice: such objects better served his contention that nature is made of cubes, cones and cylinders than would have, let us say, a swan or a rose.

This modesty of subject-matter was also a judicious choice, for the cubist, who planned to hack his subject to pieces, preferred to pick on something small that had no comeback, just as a boy intent on fun would rather pluck the

wings off a fly than tackle a bull-dog. Thus both impressionists and cubists, in agreement for once, left alone those noble subjects, historical and dramatic, in which classic painters delighted. Yet their subjects, casual as they are, differ in more than the outdoor and indoor label. The impressionist tackles a tree at the moment when the sun glorifies it into a crystal chandelier. Water, to interest him, must teem with more reflections than there are bacteria in its physical make-up. The impressionist covers nature with gauze and glitter, haloes her with trick lighting before kneeling at her feet—and, like the man who drowns his food in ketchup, leaves us in doubt as to its real worth.

The cubist takes his nature straight. Even if he rips her as a child a doll he does it with the child's serious and realistic intent. Ignoring the enchantment of light and distance the cubist can hold a pipe, a bottle, in his hand and truly delight in their shape and texture. Because he is the first man of our modern world to recognize function as beauty, the pictures painted in the 'teens of this century are prophetic of the world to be. His approach has

become that of our architects and engineers. We live in a world streamlined by the influence of those very men of 1910 whose work we now pretend is obsolete.

The cubist's choice of subject-matter is also more humanistic than that of a Monet. Monet's eye, for physical rather than for philosophic reasons, had sided with the Chinese. His mountains, streams, trees, even if they do not mirror, as the oriental landscape does, a precise articulation of the metaphysical, bespeak the abandonment of man as the center of the world. The aerial bulk which is the unspoken subject of all impressionist pictures reminds one of the wheel of Lao-Tseu which revolves around a hub of nothingness. The cubist hammered a self-centered axle into this hub: his very choice of objects was strictly limited to those in human use. Smoking, drinking, playing music were the gentle activities with which his pictures dealt. When he packed all objects tightly inside the precise limits of the canvas, as a kernel within its shell, an order born of man reigned anew. The world became cozy again, so full of solids that no inkling of the surrounding icy spaces remained.

The comeback to the mummy-brown sauce was not merely a technical quirk. It is significant that the painter cornered by a too-luxuriant creation had taken refuge in Caravaggio's cave where the retina of his sun-bathed eye could again expand to normal size. The return to the studio brought the painter back also to the friendly nakedness of four walls, a floor and a ceiling. There was utter affinity between man and his surroundings. The cubist lived and labored inside a cube.

In its early days cubism lived in the same state of mental intoxication that the early Renaissance had known. It was actuated by no scruples about mussing up the actual plane of a picture, no Byzantine taboo that would make the painting flat as a carpet. We sense rather the excitement of digging through to the back of the picture with diagonal lines moving swift and straight and interweaving like arrows in the thick of a battle. The high mental climate of the period, suggested by the monotony of the color, was repeated in the labyrinth of planes, of solids that crystallized only to vanish into other solids, exhausting all alleys of investigation. A

head, a hand was hammered triumphantly into those 64 facets which Uccello delighted to draw. His laws of perspective and Francesca's treatise on geometry are marked by the same cold fever that seized the pioneer cubists, intent on translating passion into terms of ruler and compass.

At that early stage a great future was predicted for cubism. Its quasi-scientific and factual content, especially its connection with the mathematics of architecture, made it an ideal mural vehicle. Its objectivity in handling pigment could have opened the door to the use of a group of apprentices covering a wall under the supervision of a master, as had been customary in centuries past. Its textural qualities—imitation of wood and marble, use of printed letters —had already linked it with mural painting of the sturdier sort. It should have produced a school of men who, scorning personal squabble, would have renewed the monumental arts in Gothic fashion. In a way it failed. Yet we must remember that critics had also scored impressionism for its lack of heroic achievements. They had called its landscapes and still-lives

mere sketches, trial balloons for the art-to-come that would use the impressionist technique as a tool for the expression of noble anecdotes. Some painters—like Albert Besnard and Henri Martin—who believed in critics followed this recipe for true greatness, but their names are already forgotten. One is reminded of the score of small men of the 16th century who, adding the color of Titian to the drawing of Michelangelo, succeeded only in making themselves ridiculous.

Cubism may have failed the letter of the prophecies made at its cradle but these prophecies were fulfilled in spirit. Instead of the murals predicted for churches and palaces, cubist posters perform in subways, streets and magazines. The printing press, which has multiplied the work of the cubist, has been more impersonal, more obedient to the spirit of the master-artist than any group of helpers could be. But cubism has also bred a group of mural painters, those Mexicans whose influence in turn is slowly modifying the place accorded art in the Americas, is changing it from a ladies' club topic into a potent social weapon. Cubism is linked so

organically with mural painting that, though Rivera and Orozco occupy the same position with relation to cubism that Besnard and Martin had had to impressionism, the Mexican muralists will no doubt escape a similar fate.

The later phase of cubism has been so at variance with its early stages that the movement seems like the serpent that swallows itself. But like the serpent, notwithstanding its suicidal intent, it is nevertheless nourished by its own substance. Picasso's Greek period, for example, is nearer his brown one than appearances would suggest. The same unnatural light, subservient to volume, that characterized the still-lives of his early painting days makes his human mannikins bulge. Their plaster-cast look, which made people nickname this his Canova period, obeys the same restraint which in his still-lives drained the color from the fruit and now refuses to rouge the lips of his human creations. The impassive features bespeak impersonal aims; the hugeness of limbs, the heaviness of fabrics teased by no wind, relates these bodies more closely to the cones and cylinders of his early pictures than to flesh. The 'Greek' subject-

matter is chosen with the obvious classic intent at which his brown patina of yore had aimed. He is still eagerly courting the museum.

Cubism was perhaps greatest when it was groping, trying its best, hoping. Arrived at the top it sits on its conquest, relaxes and is inclined to levity. Those formalized lines of its early stages that nestled amorously close to ruler and compass have given way to a kind of free-hand scribble; its limited palette has been succeeded by an orgy of Matisse-pinks and coal-tar dyes. The scribble is an activity natural on a scale where wrist and fingers perform it. When imitated on the gigantic scale of Picasso's latest work the movements of wrist and fingers enlarged to such inhuman size suppose as the doodler not a man but rather an air-inflated giant, *à la* Giulio Romano, come to life. The novel addition of color weakens instead of strengthening the linear skeleton still very much in evidence, brings unwanted dramatic effects which neutralize the sober core. Cubism thereby turns against itself, commits hara-kari in front of those dark romantic gods who hate its classical hide. The stage is set for surrealism.

Dali: etching illustrating Lautréamont.☞

24. SURREALISM—OR THE REASON FOR UNREASON

"Le premier qui vit un chameau
S'enfuit à cet objet nouveau"

WITH the lapse of time events puzzling in their day have a way of falling into line so that the most madcap and 'unpredictable' ones will eventually, like good soldiers, goose-step with their more sedate colleagues along the orderly paths of history. The accident or fancy of yesterday is labeled and neatly shelved as quickly as a new present is begotten. Those tempted to resent the advent of surrealism as a jog to their established routine, instead of concentrating on the strangeness of the new-born might well be thankful for the way in which, simply by being, it heaped and bound together the diverse personalities and tendencies of yesterday into a coherent whole. We can refer now to this thing of the past, the art style of the first third of the 20th century, with the same pedagogical clarity with which we speak of a school of 18th

century painting. Such generalizations are bound to falsify but come within the historian's right. It may become history that modern art up to 1930 partook of those sturdy common sense qualities, that squatty code of ethics which took the name of cubism.

The main creed of cubism was a belief in the existence of the picture as such, its autonomous right to live independent of its subject-matter in the same way, contemporary critics would point out, that a cow does not have to look like a tree to claim a right to existence. Paint was to be appreciated as pigment, the canvas was no longer the open window of impressionism but hemp or linen, woven and primed; the stretcher itself with its four square angles and the geometric relation of its sides commanded the inter-relation of lines and colors that were to come into being, bound within its rectangle. Cubist painters liked to think of themselves as craftsmen whose job it was to construct out of this wood, canvas and pigments some objects called paintings, not illusive visions but possessed of a reality like that of a chair or a table; this painter-craftsman, as craftsmen will, took to

soliloquizing about tools, permanency, recipes;
mastering the craft of painting came to depend
on technique, the respective merits of thick or
thin layers, the memorizing of geometric for-
mulas such as the 'golden section.' The cubist
sighing for an era wherein the guild member
willed to his apprentice a set of fixed rules to
work by, attempted by a cool analysis of the
works of the past to recover those mathematical
recipes and technical turns which he believed to
be synonymous with greatness. What the painter
had a right to assume as craftsman was elabo-
rated upon, swallowed bait, hook and line by
the critics who in turn educated their public
into this religion of art from the maker's point
of view—one of fetichism in all that concerns
the physical body of paint, textures that the
finger can verify, proportions that a tape-
measure will fathom.

The poor layman who through the centuries
had appreciated pictures in terms of landscapes,
seascapes, still-lives and portraits had those
switched from under his nose by the cubist critic
and was instead given, as object for his love,
anonymous rectangles dressed in a harlequin's

coat of lines and colors. At first irked by this meager fare, the public later become elated by the assumed knowledge that they were no longer mere laymen but shared the artist's most esoteric point of view. A reference to subject-matter came to be shunned as a plebeian faux-pas. A Burial of Christ by Titian, apples by Cézanne, were judged identical because they contained similar arrangements of circles and angles. It is true that a residue of subject-matter still lingered, a battered guitar or a melted bottle, but imprisoned solidly behind the cross-bars of the 'abstract' design; even emotional response to line and the dramatic suggestions of color were stifled; man was allowed to react to paint in a muscular way only, as a bull does to red.

This very excess made the job of the younger men easier, gave a good platform to the reaction. Young enthusiasts found it easy to laugh at the older cubist whose eye remained glued to lines, angles and colors with the narcissist attention of the fakir for his navel. Their elders were wrong after all when they decreed that a picture was an object and a painter a crafts-

man. For of what use would be the physical body of paint if not as a spring-board for this most noble and by now almost forgotten ingredient of art called inspiration, this metaphysical spring without which the art object could not tick. To this wealth of correlations, emotions, moods that their elders had denied, the surrealists would give free rein. An inspiration or dæmon, the wind of whose passage had materialized a century before in the embattled wig of the bohème, would take hold of them anew. The great *leit-motiv* of the romantics, life, death and love, were to be unleashed, but brought up to date within the scientific tenets of Freudian terminology: those eternal themes were now "complexes" with Greek aliases full of Germanic implications. Unlike the sibyl of old through whom the gods spoke, and unlike the artist of yesteryear whom passion swayed, the surrealist was to be dominated by his subconscious. His picture was to be a stage on which this nether world would perform.

In practice this meant that after a lapse of some 60 years during which the art-for-art slogan reigned, painting was to come back to

its old purpose of telling stories. The public
was by now fed up with sharing the personal
failures and victories of the painter struggling
within the intricacies of his craft, and sighed
with relief when addressed by the painter of
anecdotes who faced his public squarely, catered
to the layman in his own language.

The return to subject-matter is both vital
and healthy. That pigment and canvas should
be transformed into sunlight, moonlight, rela-
tives or grazing cows is magical to the utmost.
That such an amazing fact had been taken for
granted by generations of innocent-minded on-
lookers had dulled this truth to the point where
critics of the cubist generation tabooed enjoy-
ment of subject-matter as a show of childish
ignorance. It became the surrealist's easy lot to
exalt representation as being art's most magical
function. That painters and critics found them-
selves, in so doing, singing from the same pew
as all the academicians of the past did not dim
their enthusiasm, for such oldsters as Meis-
sonier and Gérôme, careful and horrid painters
that they are, had been forgotten for so long
and their works hidden with such shame that

their rediscovery held a thrill of newness like the discovery of a Grünewald or a Greco.

Most of us have seen, in our youth or at public auctions, some of those obsolete pictures smoothly finished and entirely credible, of brightly uniformed soldiers galloping heroically to their death at a lusty shout of "Vive Napoléon!" or of pink and red cardinals at a table, or (as in the case of our own G. J. Brown) of well-washed bootblacks emoting prettily. Dissimilar as their subject may be from the pictures of a Dali, a close bond links them together. Both Meissonier and Dali paint to bring forth their subject-matter and both, through a desire to make their anecdote convincing, came to adopt this same patient style, known as photographic, which attempts to be no style at all and is eminently suited to story-telling. It is strange to realize that for generations laymen approved of it as the only reasonable way to paint. It was considered a show of common sense that Meissonier in his great thirst for objective rendering would pour, one spring, sugar by the ton on the fields of Poissy to transform them into the Russian steppes needed for his

picture of the retreat from Moscow. His great
renown enabled him to borrow from the Musée
des Invalides the original redingote of the Em-
peror. On the roof of his studio he would wear
it himself, climb astride a saddle propped on a
carpenter's horse and, facing a mirror, care-
fully duplicate, palette in hand and in a real
storm this time, the snow-flakes melting on the
august relic. Dali copying a lamb chop perched
on his wife's shoulder illustrates, on a pettier
scale, the same love of objectivity by which
man, trying to impose commonplace rendering
on art, can attempt it only through uncommon
antics.

The surrealist's comeback to an academic
technique shows that he understands his job as
a story-teller. Before him Boëcklin, having se-
lected disturbing imageries for his theme, chose
also to work them out in cold blood. The more
improbable the subject-matter the more im-
pressive will be its photographic rendering, a
trick already well worn out by ghost-story
writers. But this problem of anecdote painting,
which now faces the surrealist as it used to face
the academician, involves more problems than

the choice of the correct story and the correct
model. A small-scale and patient rendering,
quaint boxed frames with glass and plush, are
successful inasmuch as they make the surrealist
picture secede from the corporeal appearance
of the large-scale, broadly-brushed painting
that preceded it, but it sidesteps the main issue.
Painting is primarily a visual art. Lines, angles,
and colors are the tools with which the painter
plies his trade; their qualities, affinities and
oppositions are the grammar of his language.
It was not laziness or lack of imagination that
made Vermeer confine himself for a lifetime of
study to a table, a curtain, a window and a
bare wall. Rembrandt had his fill with what he
saw in his shaving glass. Cézanne's life was not
long enough to round an apple or erect the cyl-
inder of a bottle. What comprehensive geniuses
then would be Meissonier and Dali who far
transcend the subject-matter of these masters
and pour onto their canvas armies of galloping
hussars or 38 bicycle riders to a three-inch
square!

It is the superficial approach of such paint-
ers to objective nature which allows them to

commit such involved feats. Their confusion of the natural spectacle with the endless chromos and snapshots that have molded their vision is a protective armor permitting them to deal with visual art and yet never to question their ready-made reflexes, never to deepen their knowledge of optics. Their idiom gives us the glyph or pictured idea of an object but not its weight, its texture, its relation to the world, its spiritual implications. They may write in paint the detailed memorandum of a plot, but the drama itself will stir us only through the language of true painting. A revelation of the problem that plagues the born painter would result in the case of those voluble story-tellers in immediate impotency. It is indeed consistent with our human limitations in other fields of research that to give the essence of things the true painter has to busy himself with few and very simple objects. Yet his is less of a failure than that of the academic painter who, though able to complete in paint an ambitious diorama, misses the inner life of his subject, gives us less than the man who recreates an apple.

In his own words the surrealist is pledged to

the conquest of the irrational. This claim, by opposing the cult of the well-ordered and of the functional which marks the achievements of the 20's, is a slap to the faith of the preceding generation; and though this may not be the reason for his stand the young surrealist would be inhuman who did not enjoy the deed. His own excess in genuflecting to unreason is partly explained by the bigotry of his opponent. The idolatrous attitude towards the machine sacrificed much that was licit when it heralded the dictatorship of the streamline, this heartless rejection of all gadgets that have no discernible purpose. The modern engineer had claimed nature as his own, pointing to the mathematical precision of the curve, the clinical whiteness of an egg. It is easy to contradict his claim, for even if a progressive bird could hatch her brood in a china bowl, the array of twiglets, straw, leaf, rags and mud with which he upholsters the nest would give her young a more proprietary satisfaction, a more mimetic contact with their own motley bodies. The smooth and streamlined egg of the engineer is after all only a device to bring forth a chick as stuffy with feathers as a

quilt of the antimacassar days. Mother Nature may be at times partner to the purist mood of a modern house by Le Corbusier, but will lapse at others into the Victorian. Our body, which like the egg and the house happens also to be a "machine à habiter," seldom uses the ruled line, the right angle, and the flat planes associated with the term "functional." The earth itself carefully clothes its mineral skeleton with blades of grass, the flutter of foliage and the mist of dew. In this sense the Albert Memorial is nearer to natural processes than a skyscraper. A surrealist picture that despises the cubist rules of surface and color composition acquires also, as a jungle will, a complicated and amorphous character, the kind of new baroque which, like the baroque of old, reclaims line and color from the too rational government of the ruler, the compass and Chevreul's rotating disc. Even the unusual subject-matter indulged in by surrealists is not irrationally chosen, for they gather to their bosom the useless things despised by their predecessors, thrown by their cruel logic on the ash-heap: a pitiful assortment of fragments—of broken

watches, dead organs, crumbled pianos; of what has outlived its function; of what repels and of what stinks.

That painting is a possible vehicle for the subconscious has long been acknowledged by the Chinese who cherish historical samples of brush writing for psychological reasons unrelated to calligraphy or literary content. For the same spiritual purpose we treasure the representation of common objects in paint if they show the hand of a master. One can make use of an indifferent subject-matter to release instinctive drama and lyricism through the passionate automatism of the brush stroke; but there is incompatibility between a mechanical rendering and the free play of the subconscious. It is strange that the surrealist who stores up as treasures bits of automatic writing, words uttered in a trance, remembered fragments of dream, does not believe in the subjective virtues of direct painting. His round-about way of using paint by taming his muscular action within the intricacies of technique kills the subconscious impulses before they reach the hand.

Painters do not have the reputation of being

intellectuals, nor is it their business to be such. Rarely original thinkers, they are however sufficiently sensitized to mirror the current thought of the day. But they need, if they are to be painters at all, to preserve a positive belief in their craft and in the world. Monet, imbued with the materialistic science of his time, shunned mythology in his landscapes but by humbling man's moods before the moods of nature he drank from the very source from which pantheism is born. Picasso, counselled by the Bergsonian quest of his own day, ripped guitars and Greek statues to unrecognition, but his zest with paint nevertheless brings forth a chaotic matter which contains, as do our very body's viscera, the disorder but also the juices of life. It may be that the Freudian analogies on which Dali props his work contain too much magic to admit of a magic handling; in this case he is less well served by his time's current thought than were his predecessors, a congenital defect which may wreck the new movement at birth. An act of simple faith remains essential to painting, be it the animal faith that the impressionist had in life or the concrete faith of the cubist in tex-

tures and lines. The Viennese haze that settles between the surrealist's eye and the world, by bringing its diversity to a shameful common denominator, disintegrates actual objects and people to such a degree that painting them becomes an artificial exercise. The saying of Poussin, "There is no painting without solid," refers both to objects and to our faith in them. The surrealist's postulate that he approaches the world with a blank mind, without the pre-ordered scaffolding that alone can hold it together, may mean an admirably impartial attitude for a scientist, but it may also mean death to that will to do without which no artist could ply his trade.

Even if the artist worships himself as a prophet or hero his approach to his material must remain that of an artisan. Most intellectual of them all, da Vinci, who did not relish this puttering with pots and pans, gave himself courage by writing that painting was a better craft than sculpture because one could indulge in it without removing one's lace cuffs or rolling up one's sleeves. Still, painting may prove too much of a manual trade to be indulged in

by the surrealist if he truly wants to deal in
the irrational. As soon as unreason is pitted
against material laws there is breakage and
hell to pay; a truly irrational architect would
see his building collapse as soon as it emerged
above ground level. The knowledge of materials,
pressure, resistance, elasticity, the dove-tailing
of blocks or welding of metal cores are essential
to the act of building. A man like Gaudi may
achieve a make-believe surrealist house whose
baroque curves remind one of lava flowing or
muscles heaving, but the same reasonable
knowledge must go into its planning, if it is to
be a house at all, as into a Le Corbusier "ma-
chine for living." Sculpture and painting, inas-
much as they have a body, are, like the house,
subject to natural laws and could not exist,
whatever their apparent content, if they were
not strictly within nature's reasonableness.

In the same way that a house, a sculpture, a
painting submit to the laws of nature, the art-
ist's body, itself one of his tools, functions on
the reasonable plan of other animal bodies, even
if the painter's tenets are the glorification of
the irrational. "Who shall add one inch to his

stature?" A lamb chop on the shoulder or the brassiere on a male chest [1] cannot deny the inner anatomical architecture which through the arm, wrist and fingers may communicate itself to the picture, pollute with its good health the psychopathic intentions of the author. A hand working freely, as in the case of Monet, gives to painting a healthy animal tang which would be rather at odds with the tenets of surrealism. Hence the search for safer means which will preserve a purer brand of unreason and in which the hand is no longer concerned: photo-montage, print-collages, rubbings, through which the thought or vision may somehow express itself without being straightened and strained through the sieve of organic experience. Thus Max Ernst enthrones himself amongst a hodge-podge of 19th-century wood engravings, daguerreotypes, and hardware with the same royal nonchalance as the hermit crab lodges in the shell of a deceased mollusk; and with pastepot and scissors injects unexpected meaning into those old things. The fear of autography grips even those surrealists who, somewhat suspicious of the ready-made, still produce their pictures by hand. The

[1] Worn by Dali at a surrealist ball.

extremely cautious brush stroke of a Dali is truly as inert as the cut-outs of an Ernst. The fragments from old masters, from snapshots, from anatomical plates that constitute his stock in trade recur time and again in his pictures, identical but in shuffled order, reminiscent of the franker methods of a montage. One step further towards impersonal handling and we have the modified objects—furred cups and similar freaks.

Yet even if you kill the hand unreason is not saved, for the skeptical could argue that our brain itself is as much a part of nature's scheme as our hand and that, prisoner as it is of the universal logic of creation, its efforts to escape are probably inadequate. A surrealist scene can be fabricated simply by inverting the relative proportions of normal objects and situations. Our grandfathers' favorite was the painting of a cardinal eating lobster at a lavishly garnished table. If we shrink the cardinal to a size where he would fit at ease on the plate and enlarge the lobster until it fills the prelate's armchair we have a typical paranoiac picture which satisfies the most exacting standards of the

good taste of tomorrow. Just as a photographic negative, though it paints nature's white black, can boast of little fantasy, and just as the devil may be said to ape God, the too logical unreason which happens to be reason reversed has little claim to be an irrational process.

It would seem that the perfectly unreasonable picture could be the work of a madman only, but few such genuine creations fit easily into the surrealist bracket. Madmen go wrong at one point in their reasoning but as soon as they have branched away from the main road they follow their erroneous path with tenacious logic. The surrealist unlogic occurs rather in those relaxed moods of dream and day-dream which are typical Freudian hunting grounds. The two operations conducive to such moods are, first, a conscious state in which a store of images accumulates in us, to be released in apparent disorder in the second, subconscious stage. Consider the two operations necessary to the functioning of a mechanical toy: the grim expression and muscular effort that attend the winding of the spring, reminiscent of our articulate activities, contrasted with the disor-

derly, noisy, comical animation that attends
the uncoiling of the spring, and that is similar
to our dream mood. Subconscious vision pro-
ceeds, like movie fade-outs and fade-ins, by
swift, unrelated changes of scenery. Its objects
have a lack of tactile reality. No medium is
elastic enough to describe this dream world.
Cinema can approach only its tempo; words are
too rigid to fit shifting meanings. Painting,
with its static monumentality, is perhaps with
sculpture the least fitted of mediums to describe
it accurately.

The man who embarks on a voyage into the
Freudian realm with the too innocent faith that
the new land, however fanciful its vistas, is the
wholly natural phenomenon of a release from
inhibitions, is bound soon to be disturbed by an
imperceptible passage into the psychic. There
the soothing voice of the psychoanalyst gives
way to the scratchings of automatic pencils in
the dark, the fist of the expounding professor
is replaced by the raps of turning tables, the
text-book is superseded by visions and voices.
Reason may be clumsy but it acts as a useful
ballast for anchoring within the natural our

humanity prone to flight. Having first divested himself of his armor of logic the superrealist comes nakedly face to face with the supernatural. To push forward with blank mind into the jungles of the irrational is to annul those centuries of bitter experience through which men at a dear cost sifted and labeled psychic phenomena, came to distinguish between what makes witches fly, were-wolves howl, John unroll his Apocalypse and Joan deliver France. Tradition, even if it be called old wives' gossip, would have been useful in charting the new country. Fra Angelico knelt in joy when the angels held his brush but a surrealist will rejoice as much if some Ouija board entity dictates his picture. Unconcerned with the obvious implications of his own oath that he acts as medium, he views with satisfaction and profit the fruits of his labor, those representations of putrid matter, rancid bones, which to the uninitiated resemble a streamlining of the horns, tail and hooves of the devils of a less credulous age.

Schools of painting have always had their main reality on paper. Painters have been bunched together according to their date of birth rather

than an understanding of their 'œuvre.' Thus the
sculpturesque Renoir nestles with the impres-
sionists, the Whistlerian Braque is labeled cub-
ist. Surrealism is also the wish-fulfilment mi-
rage of critics. If we look at personalities its
entity weakens. Its most doubtful exponents
are those older painters who were already com-
mitted to a personal style when surrealism was
born. To eulogize their work ten years ago for
lyrical or emotional reasons would have seemed
misplaced and even libelous. They had led the
cubist movement but cubism was fast becoming
old-fashioned. The simplest way to keep them
up to date was to change the label on their
goods. Chirico's early work was hailed within
the cubist movement for its building up of ar-
chitectures with compass and ruler, its rigid
perspective, its mathematical symbols, its house-
painter's way of laying the paint flat. It is now
lauded for its mysterious moods, sexual innu-
endos, disquieting titles. Picasso's work was
more difficult to reinterpret because of its ob-
vious plastic soundness, simplist subject-matter
and good-humored craft. Some person, however,
did a good job of it who, by changing the title

of a cubist "Bather" to "Metamorphosis," packed it chock full of menacing implications. Between this blatant misuse of cubism to make it appear what it is not and bona fide surrealism there is a twilight fringe of painters, lacking the constructive solidity of the one as well as the literary frills of the other. The gay Miro, Masson the sad, can be made to fit in either camp. The melancholy offerings of Tchelicheff and of Berman are too close to a Whistler Nocturne in mood and means to fit easily into the surrealist bracket. The more genuine surrealist picture should exhibit a cluster of haphazard objects realistically achieved. Though Pierre Roy is the pioneer of this comeback to a *trompe-l'oeil* his work is so bathed in French lucidity as to starve the amateur of unhealthy complexes. Dali alone, by telling strictly horror stories or worse, fulfils all the expectations of the surrealist fan.

Men who wish for sausages get them hanging from the nose. When Picasso some 15 years ago sighed that "Art is in need of David" he was voicing a desire for the reappearance of subject-matter, for a more objective rendition,

for more craftsmanship in paint, conscious as he was of the defects of his own ego-swelled, sketch-mad era. No David but a Dali appeared in answer to this wish. Yet even though the new school features the sausage-shaped appendage reminiscent of the apologue instead of the Roman heroes dear to David, it brought back under this vile disguise some of the reforms that Picasso was asking for. The return to subject-matter and objective rendering is pregnant with consequences, re-educates the public into this only proper way for it to look at a picture. Compared to such a boon the kind of representation offered, offensive as it may be to some, is inconsequential. The artist ceases to be the egotist shut up in his tower. He must now come down from his pedestal into the street and gather a public to tell his story to. Surrealists reaffirm also the truth that art, whatever the manual labor involved, is pre-eminently a spiritual affair. They rescue from the too-physical armory of the cubist achievement this minute seed, this soul without which no picture of any school could live. That the artist needs a dæmon is of course no surrealist discovery, but the sur-

realists were brave enough to single out this fact from the discarded bric-à-brac of truths shelved by the cubists. The artist who yields to inspiration can no longer pretend that he is concerned only with himself and his own art problems. He becomes a channel for some agency more universal than himself. But though in the art-for-art achievement the artist could only hurt or ridicule himself, in art with universal implications his public too may be damaged. If his objectivity concerns only the social beliefs of a group the artist's only duty is to be accurate. But if he delves deeper into inspiration, or as we say now, follows the dictates of his subconscious, his manner approaches that of the prophet or the sibyl. For his own hygiene and that of his public he would do well in such case to be choosy as to what gets hold of him.

25. FROM ALTAMIRA TO DISNEY

ANIMATION in art antedates the advent of the cinematograph. I do not mean here the still representation of figures in action, as happens in sports photography, but the mechanical illusion by which a painter produces an optical movement within his canvas, comparable to an extent to cinematographic action.

A painting is static by rule. It seems that a suggestion of animation would interfere with the enjoyment of the painted surface, those re-

lations, affinities and contrasts, between areas or colors. Some of the masters have wisely hesitated to bring movement into painting for fear that it would disturb their timeless architectures: Piero della Francesca, George de la Tour, may be called the masters of immobility. But we must also give thanks that a spirit of adventure carried other artists a little further than their actual means would strictly imply. A total purist should limit himself exclusively to the two dimensions of his canvas. That an immobile design should be endowed with apparent animation is no more artificial than this other subterfuge of modelling and chiaroscuro by which the painter suggests three dimensions on a flat surface. Yet make-believe volume and space has become so essential to occidental painting as to be taken for granted, while the problem of animation has either been omitted or receives casual treatment.

Animation need not be the corollary of a subject matter, for it begins with the very birth of an art work, pervades even the barest geometrical scheme. A line, as Klee puts it, is a dot that has been taking a walk. An area or plane

can be said in the same way to be a line that
has been progressing crab-wise. And volumes
are generated by the gyrations of planes. Those
are not theoretical divagations, but the prac-
tical means that the eye uses in the act of
sight. When we "follow a line" we play at be-
ing the dot that engenders it. When we experi-
ence a proportion it is by sliding the compo-
nents into comparable positions. Even the bare
canvas has such potentiality. When we compare
the side AB to AD it is by swinging optically
B around A as center until it reaches the posi-
tion AE, ED being the residue or symbol of the
aesthetic sensation. The arrow on the diagram
is not a decorative addenda but the admission of
this cinematic truth. A fan formation of lines can
be read as static perspective lines, may mean
also that a single line is swinging with a pendu-
lum movement. In that sense, the tipped tables,
bottles and Mesdames Cézannes of Cézanne effect
in our brain a constant swing between the ver-
tical that they should be and the diagonal that
they are, while if all was plumb perfect and
true to gravity, the picture would sink into a
static state. As we saw, even straight figures

sliding around fixed points are bound to leave a circular trail. The curved line becomes thus the trade mark of the painters who thrive on movement. Tintoretto, El Greco, Daumier, materialize those optical tracks into brush strokes. As a result their painting conjures a "tempo" as does music and the dance.

Similar figures drawn at different scales suggest that a single figure is receding in space as it diminishes in size. The rectangular map or mirror that Vermeer hangs on a bare wall is the rectangle of the picture itself which has taken a fling in depth.

When we switch from those abstract movements to motion as an aid to subject matter, we find that even inanimate objects have to submit to animation in painting for descriptive purpose, for motion is our prime way of investigating form. To grasp optically the shape of an object our natural course is to multiply our points of view. We roll dice held in the hand until we have observed all six facets and checked up on their numerals. We manipulate the drinking glass we buy so as to observe the circle of its base, the circle of its rim, the profile of its

cylindrical body. We shake or manipulate small things but in the case of heavier objects, a sculpture, an automobile, we ourselves walk around the immovable object, which comes to the same result in both cases, that of observing a solid from a number of instructive points of view.

This procedure is impossible to apply to the observation of painted volumes. The more perfect the imitation of a given volume in paint, the greater will be the desire of the onlooker to investigate further, the greater his disappointment as by shifting his position to the side all he comes to observe is the canvas flattening into a paper-thin profile. So that it is the painted object, if it is to be investigated at all, which has to move to and fro in front of the immobile spectator, exhibiting its front view, profile, ground plan, etc. It is for this reason that as far away as we can follow artistic tradition, a very few primary shapes fitted to this purpose have been preferred by painters who singled them out of the confused profusion of natural shapes. A painted sphere is as complete and satisfactory a description of sphericity as a

sculptured sphere, for a sphere remains identical to itself from whichever point of view. Raphael who in his own words sees "that Nature tends to the circle everywhere" smooths into this circular dream even the square canvas which he prefers as round tondo, "spheres" the heads of his madonnas with the same partisan fire with which Picasso cubes his. Next to the sphere, the cube and the pyramid satisfy this law that a volume fit to paint should give a candid account of itself even from a single point of view. Each of those shapes is to itself front and profile view, top view and ground plan.

In the case of those chosen few, no need is felt of forcing into artificiality the natural appearances. The choice of shape at the start assures naturally the multiple point of view which is tantamount to movement.

When we come to informal shapes, their complete description with paint is attainable only through artifice. The minimum description of a drinking glass comprises two circles, its bottom and its rim, one rectangle, its pure profile. The bottle must show a circular ground plan, the smaller circle of its lip, an architectural draft

of its profile. Though fearful of the opinions
expressed by academicians, Cézanne solves this
problem of the glass and bottle by queering the
perspective of his objects. This master drafts-
man forces the rim of the glass into full vision
by "bad drawing" if need be, deposits precisely
at the bottom of the bottle an orange whose
circle is the makeshift image of the bottle's
ground plan. A man less humbled by Nature
than Cézanne, Picasso is bolder in his means:
he amalgamates within one hieroglyph the
unrelated points of view; that the result be
puzzling is not to deny the thorough realism of
the cubist intent.

As a link between this investigation of static
volumes and mimicry proper, we have the bor-
der case of Degas. Wishing to paint one of his
own sculptured models of dancers, Degas could
not sum up into one single point of view the
plastic diversity of his statuette. Instead of
evolving a composite image, as the cubists were
wont to do later, he did, in one painting, repro-
duce his sculpture as three or four separate fig-
ures corresponding to strategic points of view.
Such are the three dancing figures known as the

"Danseuses Vertes". They do not truly move, but should be read as one single figure which, on a revolving platform, describes a quarter arc of a circle before our eyes.

True animation concerns the gesticulations and displacements of living bodies. Simplest perhaps are those cases where the body remaining in one place, movement affects only the limbs or features. The genesis of such illusion may have been those pendimenti by which an artist, sketching quickly, superimposes three or four movements of his model. Such is this Mayan charcoal sketch where the face of the god is a composite of two sets of features, one benign, the other wrathful.

Another equivocal field where animation may happen as an accidental is that of scientific diagrams, such as the one in which Leonardo squares and circles a human body whose arms and legs in their two distinct positions suggest a working model for setting-up exercises.

Theology also does its bit. Theologians conceived the Hindu Shiva as having many arms to signify specialized powers. Ignoring those intricacies, the Hindu parishioners must have feared rather the dynamic effect of this wheel of arms precisely articulated at the shoulders, suggesting an ample and evil flapping as of two wings filmed in action. The composite Trinity of Flemish origin embodies a recondite dogma, but it is also one head whose circular movement majestically surveys a whole horizon.

In each of those three genres, pendimento, science and religion, the optical illusion obtains even though it is not the essential intention. But in other diagrams, the artist's aim is to produce such illusion. The wild boar painted in the caves of Altamira is endowed with four pairs of legs, two in running and two in crouching posture, the two tempos of a gallop pur-

☞Composite Trinity, XVth C

posely filmed a few thousand years ago by the
quick eye of a hunter. Greek horses drawn on
vases are arranged so artfully that out of one
body many more heads and legs emerge than
an anatomist would vouch for. The legs are
seen prancing briskly, the head shakes its
mane and rattles the bit. The artist uses the
privilege of his archaic status to dabble, more
than an academician could, in cinematography.
The futuristic dog of Balla, the walloping fist
of Popeye multiply also legs and arms through
movement. This is optical realism for the cam-
era duplicates those effects if the sitter refuses
to be still and the shutter is slow.

Other means to produce animation are less
realistic, more strictly confined to mental proc-
esses. In Picasso's "Enlevement" two bodies are
interarticulated in such a way that limbs are
seen moving around knee and elbow, the fore-
arm and leg being represented in two positions
each. Picasso introduces here two people, and
by double meaning produces movement.

When movement is accompanied by transpor-
tation, as in walking or running, the artist comes
to use the cinematographic principle: a proces-

sion of beings, each illustrating statically an
instant of motion, is equivalent to one single
being in actual motion. We have thus a Chinese

ink scroll of geese which are also, when read from right to left, a goose in flight, its wings passing by transition from their upright to their downward posture. We have the Mayan warrior caught in five successive "stills" of his war leap, in the frescoes of Chichen-Itza.

The more complex scenario of the kind attempted in painting is Dürer's woodcut "King Sapor and the Forty Thousand Martyrs". The action makes use of as many figures as there are Hollywood extras, to animate the single actor. This composite Christian walks with diminishing strides until he reaches the edge of a cliff. His arms shoot upwards. With feet clinging to the rock as a hinge for a circular and clockwise movement, the body swings into space. The fall follows, until the martyr impacts the lances of the executioner waiting below, and collapses through four downward stages into death. It is edifying to compare Dürer's 'short' with a movie of a man diving, the parallel sequences dovetailing to perfection.

A similar though simpler strip of action became notorious in our own age: Duchamp's "Nude Descending a Staircase" for which

this article traces a tradition. Unlike Dürer, Duchamp refuses to make-believe that many people are involved in this descending motion. His rigorous logic conveys not only the diagonal sliding of the single body in space, but even the shifting of the weight from hip to hip, and the balancing movement of shoulders and head.

When the plot becomes further involved, the optical dynamism obtained by abstract composition weakens; the artist needs to rely more on the onlookers' good will to read the tableaus in proper succession and timing. Such are the predellas relating episodes in the life of a Saint, the fourteen stations of the Way of the Cross, the page of "funnies" in our Sunday papers. We shift from the realm of painting to that of story-telling.

The cinema has made possible for us an extreme complexity of timing and movement impossible to reach by other means. Yet the urge of man for a dynamic art could not wait for the scientists' permission to perform. The cave man who 'animated' the boar of Altamira would have hugged with reverence this other animalist, Disney.

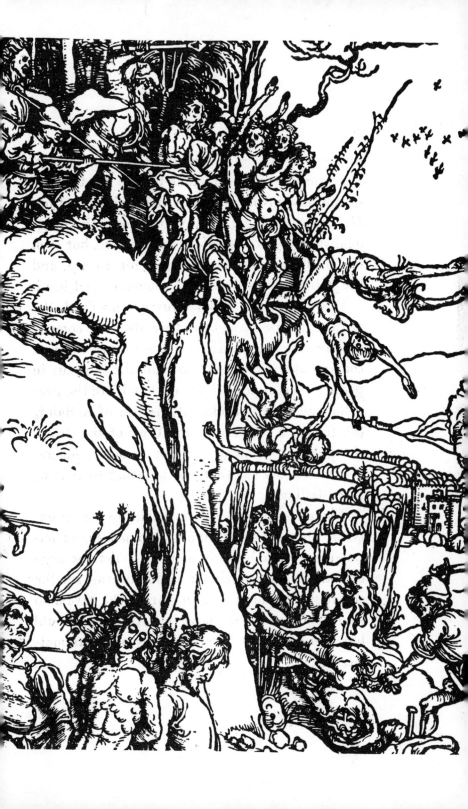

☞Dürer: "Christian Martyrs."

26. A DISNEY DISQUISITION

THE problem of animated drawing does not date from the advent of the movies. Cinematic animation, however artificial its relationship to the static medium of painting, has tempted artists from the very beginning of human time. The boar of Altamira, galloping on four pairs of legs, is echoed across the millennia by Balla's futuristic dog whose legs in action resemble two full-pleated skirts. Giotto suggests actual gesticulation through key postures. It takes two people out of his crowd to act despair—one with arms raised and extended, the other with arms and hands gathered forcefully to the head. Picasso, battling against the resistance of his medium to the expression of mechanical movement, brings forth obscure palimpsests of superimposed images. In a subtle way, when the rigid line of the classic gives way to the loose contours of the romantic, the released line frees the painted personage from his carcan of geometry, allows his muscles to ripple and his breast

to heave. The baroque masters go furthest into movement—use turmoil as a rule of composition.

It is no superficial urge that makes a painter crave animation, but an essential one, as deeply rooted in our nature as the sense of width, height and depth. As Dr. Carrel bluntly puts it, man lives physically in a world of four dimensions—the three that can be measured with an inch tape and the fourth with a watch. Time, in effect, is a condition of our being. The curved graph that our body traces while growing from ovus to manhood and receding into dust is vitally ours, impossible to conceive outside that element. So too are its pettier daily gestures. A measurement of height and weight describes us only in terms of a given date. Any family album of snapshots shows a single entity—the tottering baby, the college boy, the bridegroom, the happy father—in the guise of diverse and unrelated bodies. These are selected slices cut into a trajectory through time, into a fourth dimension so physical that, like the other three, it is not outside the camera's reach. The world a man paints is optical, a strictly physical world of objects and bodies. The painter can-

not, like those artists who deal in words, treat of time in its imponderable essence. He cannot, like the family album, suggest it over long periods. He can catch time only at its point of impact with the other three dimensions, when it clothes itself in movement.

Because approximate means of animation have been routine among painters for centuries it is difficult to believe that, when a more convincing means has been evolved, its use will bring us (as some suggest) from fine arts to a nondescript bastard medium into which art critics will not dip. Of course animated drawing differs from painting and sculpture, but will remain art inasmuch as its new freedom brings with itself its own limitations. The main difference between immobile painting and cinematic drawing lies in the fact that the element of time which is artificial to the former becomes one of the essentials of the latter. In this sense animated drawing partakes of the qualities of music, poetry and the dance. It must be appreciated not only in terms of simultaneous proportion, as in painting, but also in successive tempos that have a beginning and an end.

The animator had mostly to discard the classical shapes cherished by painters—the sphere, the cube, the cylinder—for the very reason which makes their painted excellence: Raphael's beloved sphere, Seurat's canon of beauty, the cylinder, remain unchanged in shape from wherever they are seen. Raphael's Madonna, Seurat's "Promeneuse," could look only dull if whirled on a screen for, beautiful in repose, they are no more adapted to movement than an Ionic column. Sculpture and cinema call for surprising changes of form as an accompaniment to the shifting of points of view. Let us say that a piece of pie is a classical shape for the purposes of animation inasmuch as its top view is triangular, its side view rectangular and its periphery circular. In Disney's "Ugly Duckling" we see a decoy duck floating over the waves. As the duck bobs up and down our point of view changes vertically from ground plan to airplane view while the shifting currents that carry it into a circular movement familiarize us with both its sides. We get out of this thorough observation of its illusive and complex volume the same aesthetic enjoyment

we should derive from handling and patting an African carving.

In painting we get a sense of proportion when one volume is compared with others. This is also true of animation, but here a volume can also compare itself with itself in time. Disney handles this comparison most successfully when he uses abstract volumes—for example the swarm of bees who shift their strategic attack on Mickey from pyramid to sphere and back to pyramid. But the same observation holds true of all the actors. A thinnish personage rotating, both arms extended downwards at a forty-five degree slope, transforms himself into a cone perched upon the stem of his legs, a human Christmas tree. When the arms are extended at an angle nearer to the horizontal, the rotating body becomes a parasol. If the arms are raised upwards at a forty-five degree angle, the rotating shape is that of a chalice or funnel.

This sort of transfiguration may sound like a parlor game but has deep plastic significance. Whereas sculptor and painter perforce treat constant shapes, the animator (without needing to use an abstract language) can at will

bring into being and discard the series of shapes which the body in movement creates as naturally as the mouth spouts forth words. This plastic language depends on the degree of the relationship between the evoked shapes and the mother shape. A cylindrical man may use cubic gestures; a thin man may revolve himself into spheres. The modification may be less obvious—it may be a slight shuffling of the component measurements, the swelling of the chest, the rolling of a muscle (or, in a close-up, the movement of an eyelid over the sphere of the eyeball). Contrasts and affinities make up a language of movement as suggestive as the language of line or color.

Animation portrays the rolling of waters, the mutiny of fire, the growth of spring, whereas the painter is bound by a set of childish symbols—the wave, the flame, the flower. To use the Chinese terminology (which recognizes constant form as distinct from constant principle), painting can tackle the form but only suggest the principle, whereas the principle is well within the range of animation. When Cézanne tips Madame Cézanne and her chair, we can

check their unnatural angle only against the
rigid verticality of other painted lines. When
Titian in his "Baccanale" places a wine-glass
in the hand of a Maenad he opposes the tipsy
diagonal of the stem to the horizontality of the
liquid level. The animator does not have to op-
pose line to line but, more richly, lines to law.
In a drunken scene the animated drunk bat-
tles against the vertical pull of gravity, makes
it the very real if invisible prop against which
he essays dangerously diagonal attitudes. The
wine-glass he carries can multiply its angles
graphically in a pendulum movement set against
the immovable reproach of a horizontal liquid.

It has been said that cinematic movement will
weaken painting by bringing an added natural-
ness into the medium. Were there no bounds to
means we should, it is true, have nature instead
of art. But movement brings in the element of
time and time is a discipline in itself. The elu-
sive time which a painter may conjure up slows
down or hastens its pace at will, for it is a sub-
jective time. But the time which the animator
has to deal with is time measured by a clock. It
reigns implacably within the work of art as it

does in our life; the artist cannot manipulate it but can only toe to its beat. The addition of movement gives freedom of a sort to drawing but it also constructs new boundaries. Since the "short," to be of commercial value, must be compressed into a seven-minute duration the artist is forced into the concision and precise dosage of moods that one finds in a Japanese "hai-kai." Artificiality is restored.

The space within which the painter sets his volumes does not call for much elasticity as a counterbalance to their static pressure, for his means include those delicate gradations and veils of air with which a Rembrandt, a Monet, suggest infinite recessions. The animator can also lick and polish his backgrounds with tonal washes until they are as spatial as a painting. But when the drawn puppet steps onto this highly refined stage his blaze of color, his mesh of black outlines, give the lie to the refined setting out of which he has hatched. In order to live and breathe the puppet must create a more functional space around itself, and gesticulation is the only spatial means within its range. With its legs and arms the cartoon creature

pushes away from itself the flatness of the screen that would engulf it, proves space to itself and to us by whirling and running. Like the water-insect enclosed within its own airbubble, the puppet lives within his subjective private space.

Here is reconciled the clash between the cubists, who would limit a picture to its rectangular outline, and the impressionists, who view the rectangle as a window opening onto unlimited vistas. For the moving screen (responsive to the settings demanded by promenades and pursuits) may at times unroll dioramas vaster than those of a Monet; whereas at other times the scene may be so rectangularly circumscribed by the boundaries of the screen that the personages who rush against the walls, ceiling and floor of that cubist heaven bounce back with broken ribs and bleeding noses. The moving picture has here developed a new plastic theory, that of contrast, and the two great schools of thought that painting bred are equally good ingredients for the cinematic sauce.

Peculiar laws govern the landscape in which animation takes place. Although in real life to-

pography governs our movements, in the realm of animation the trees, houses, furniture, are all born of, or submit to, our own movement. There may be any number of trees in a landscape but they efface themselves from the path of a running creature. Or if a bump there must be they pile up on the track. Objects have no other weight or texture than that proved by their contact with movement. Of two similar walls one will be passed through as in dream whereas another will provide a harsh fall. People obey the laws of gravity when need be or they float in air or multiply themselves till they are in three or four places at once. This high-handed use of natural laws to suit special purposes effects a release in us more joyful than any gag. We who have suffered since birth from an incessant pull at our coat tails by centripetal forces, who tiptoe through life avoiding evilly-set obstacles, rejoice when flung into the world of animation where our moves impose their own elbow-room over all creation.

Poussin built up small maquettes of places with mannequins propped up at given points and thus established his horizontal composition

on ground level before he collapsed the whole
scene on the window-pane of the vertical can-
vas. But not even the severe calculations of a
master can overcome the congenital weakness
of painted depth—at best only a poetic ap-
proximate to physical width and height. Depth
dwells in animation as sturdily as height and
width, its trail spun under our very noses by
the personage in action. Painters who know
that depth is a lie use it with discretion, plan
spatial compositions that are relatively simple
when compared with the refinements of the sur-
face schemes they develop. Animation, by re-
moving their scruples, makes complexity legiti-
mate when they are composing in depth.

Just as a painter composes with physical
volumes, an animator composes mainly with
diagrams based on motion. The continuity of
movement as stored by the retina is a picto-
graphic language, related to the moving source
as slightly as, for example, figures cut on ice
are to the skater. More exactly, composition by
movement, since it is in three dimensions, could
be compared with the luminous trail left by a
swiftly moving cigarette tip in the dark. Its

scheme, moreover, can be more severe than that which the natural form admits of. Who has not thrilled at the spiral into space evoked by the gyrating musicians caught by the cyclone in "Mickey's Band Concert"? No one would be more delighted by it than Hogarth; for here at last, in its three-dimensional reality, has been realized that Line of Beauty, the S shape which, with the imperfect techniques of the painter, Hogarth strove to wind into space by coiling it around a superfluous cone. That spiral which the painter can only hint at and the sculptor can only freeze, animation brings to life.

In discussing the new medium one dreams of endless achievements. It has been suggested that in the hand of a Michelangelo animation could evolve Sistine Chapels; that if this came to pass all the work painted in the pre-Disney era would become as obsolete as stereoscopic views in our decade of 'talkies.' But the actual use to which animation has been put is perhaps not so much the first mouthings of a wonder child as a classic flowering of the medium. The gesture of the Sistine Christ is beautiful because of its arrested motion; its timing and comple-

tion would bring it down to the range of acci-
dentals. On the contrary Donald Duck could
gain nothing by being frozen into architecture,
for his soul shines brighter amid fits of motion.
Animation needs to treat a gesture as continu-
ously in the making; its actors must strive and
quibble on a plane low enough to make events
or inanimate things conspire against their en-
deavors, corner them into muscular reactions.
When the Mouse has triumphed over its ene-
mies and enters into Beatitude the 'short' is
over, the fade-out nears. For Mickey steps thus
out of the range of the animator, enters the
static realm proper to other arts. Michelangelo
could not have conceived his heroes at a stage
previous to apotheosis and might therefore
have been a poor man to handle the fluid me-
dium ·of animation. But it is also true that ba-
roque minds—a Greco, a Magnasco, a Daumier
—who worked in a static medium but were
haunted by dynamics, would have welcomed
cinematography.

In the movies a comic angle and functional
beauty are one. The shape that genuinely ani-
mates, that brings swift changes from profile

to front view and is elastic enough for gesticulation, may have to be funny. The motive, and the shape which implies movement, pull the screen personage from the severity of the permanent into the continuous surprise-party of the impermanent. Disney's creations are no vagaries. They are shapes modelled strictly along the lines of their function, and their function burgeons into beauty. When Doc turns around and the sphere of his skull melts blushingly into the twin sphere of his nose, one gets an impact of functional beauty. For Doc is as fully consistent with the cinema as Raphael's Virgin is consistent with paint. Beautiful art must be conditioned by the medium, as our own body is by function. To have flowered into appetizing womanhood, Galatea must have started out as a very poor piece of sculpture. When human shapes—Snow White or the Prince Charming—are seen side by side with Disney shapes on the screen, it is the human that suffers.

Where plastic language is concerned this newest of arts is a major achievement. The painted fan, the radiator cap, may be a reflec-

tion of the major art trends of the day, but animated drawing is a microcosm of style complete within itself. Though its evolution follows the graph drawn by the history of art, it does so at its own regal good will, in a tempo that within a very few years has telescoped the primitive, classic, baroque and decadent styles which painting took centuries to investigate.

The earliest animation, though the story was jammed with gags, confined itself with a Giottesque severity and decision to black and white. Backgrounds evolved more rapidly than personages from this 'primitive' stage because their handling made smaller technical demands upon their creators. They ran through a whole gamut of styles, only to nestle finally, and triumphantly, in a ladylike photographic rendering. Personages, which labored under the handicap of more involved technicalities, made slower progress. They have now reached a stage where local color has been added to the black outline, where they resemble Gothic windows whose opaque leading partitions light into color. The animated beings of today and their creators seem somewhat absent-minded apropos

this archaic glory which is theirs. Alas! some new technical kink may yet rid them of their rigid outline and permit them to melt into their background, long seated on the lap of the Academy. We have already seen the seven dwarfs, emerging from their cave into the sunset, shed their flat Gothic livery for the contrasting light and shade of the High Renaissance!

Cubism had dreamt of an impersonal art that would replace the free-hand line and the open-brush stroke with patterns appropriate to ruler and compass; that would substitute flat areas of tone, as bare of individuality as a newly-painted wall, for subtle shadings. Since works of this sort could be multiplied by mechanical means the world might at last rid itself of the idolatry of the "original," might resuscitate ancient collective traditions, Gothic and Egyptian. Leger, Gleize and Gris came close to realization, but neither dealers nor collectors wished to endorse an art that was not for the few. Though the cubists had evolved a means, their art-for-all dream, their cathedral, was side-tracked on its way.

Without benefit of critical appraisal, and

whipped into form by the pressure of balance sheets and the profit motive, the animated cartoon is nevertheless the unexpected flowering of the cubist seed. In this cartoon the impersonality of a work of art has been captured, the cult of the "original" has been smashed. The drawings are manipulated by so many hands from the birth of the plot to the inking of the line that they are propulsed into being more by the communal machinery that grinds them out than by any single human being. A first draft for a film reveals the creative heat through its pendimenti, erasures, clinical additions in blue or red pencil; it goes further into the alchemy of transmuting form into motion than did many of the Masters. But this holography, which makes the sketch worthy of a Museum, is still not sufficiently purified for the severe standards of the cartoon. Personality is squeezed out through multiple tracings until the diagram, its human flavor lost, becomes an exact cog within the clockwork. The key drawings are cross-sections of each gesture at its mechanical and emotional climaxes. Numerous hands patiently perform the intermediates until the flow

of images, so many to a beat, parallels the tempo of the sound track. Time, the fourth dimension, is the conductor which orchestrates the great volume of drawings and files them into a coherent whole. Far from a free-for-all, this motion-art composes not only in the media of surface and depth, but uniquely and rigidly in that of time.

Truly an art-for-all, these great murals that move are pets of the people. Ucello's gigantic horseman has become green mold on its smoked wall; ancient frescoes are entombed in deserted museums. It is altogether fitting that new murals should emerge in those places where the living congregate. The new subject-matter illustrates the sharp cleft between our rationalism and our imaginative urge. We work, love, eat and sleep within a riddle of financial pursuit, our brains overbrim with common sense. We bow to this newly created pantheon of animal godlings, Mickey Mouse et al., for they are different from us, godlike, irrational.

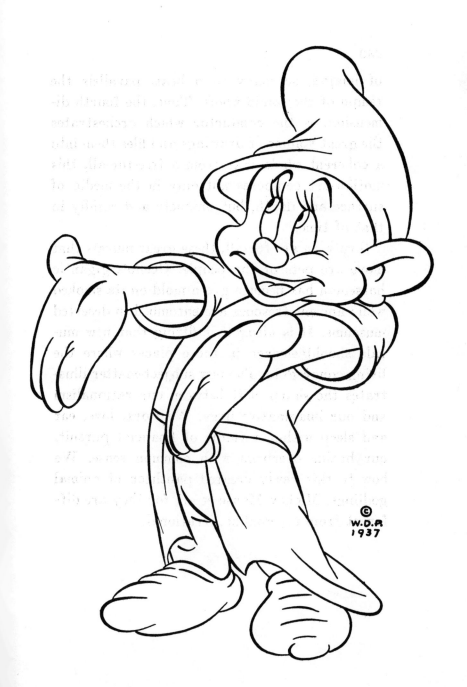

☞ "Dopey."

*The text of this volume is made up of the col-
lected articles published from 1923 to the present.
Those dealing with Mexico have been translated
by the author from the original Spanish with the
exception of Nos. 4 and 8, which were written
originally in French. The text in some cases has
been modified or expanded.*

*A list of periodicals and magazines in which they
first appeared follows:*

284